UNDERSTAND THE CONCEPTS THAT FORM THE FOUNDATION OF DRAMATIC PAINTINGS

by Ramon Kelley

The 5 ESSENTIALS in every POWERFUL PAINTING

international
artist

international
artist

International Artist Publishing, Inc
2775 Old Highway 40
P.O. Box 1450
Verdi, Nevada 89439
Website: www.international-artist.com

Edited by Jennifer King
Managing Editor Terri Dodd
Designed by Vincent Miller
Typeset by Cara Miller and Ilse Holloway

Library of Congress Cataloging-in-Publication
Data

Kelley, Ramon, 1939–
The 5 essentials in every powerful painting /
by Ramon Kelley.
 p. cm.
 ISBN 1-929834-12-8
 1. Painting— Technique. I. Title: Five
essentials in every powerful painting. II. Title.

 ND1471.K45 2001
 750'.1'8—dc21

 2001024296

Printed in Hong Kong
First printed in hardcover 2001
05 04 03 02 01 5 4 3 2 1

Distributed to the trade and art markets
in North America by:

North Light Books (an imprint of
F&W Publications, Inc.)
1507 Dana Avenue
Cincinnati, OH 45207
(800) 289-0963

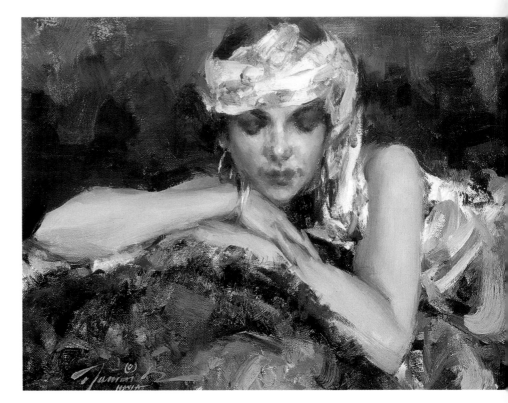

"THE GYPSY", *OIL, 11½ x 15½" (29 x 39cm)*

Contents

The 5 ESSENTIALS *in every*

When I was a young student artist, I believed other artists knew secrets they weren't telling me. But they didn't! As I've continued to paint for many years, I've found they were all using the same handful of essential concepts that anyone can use to make powerful, unique paintings.

In this book I'll show you what those five essential concepts are. I'll show you how to design a dynamic composition with just a simple arrangement of shapes. Then I'll teach you to use a simplified approach to value, color and texture to bring out the three-dimensional form in your subject. And finally, I'll explain how to use many forms of contrast to create excitement around your painting's focal point.

ESSENTIAL # **1**
Composition

Create a foundation for your paintings by seeing and organizing the big, dynamic shapes according to direction, balance and integration.

ESSENTIAL # **2**
Value

Value has two important purposes. Use value to create the illusion of three-dimensional depth in a painting. Then use value shapes to provide a unified structure that leads your viewers back to the focal point.

POWERFUL PAINTING

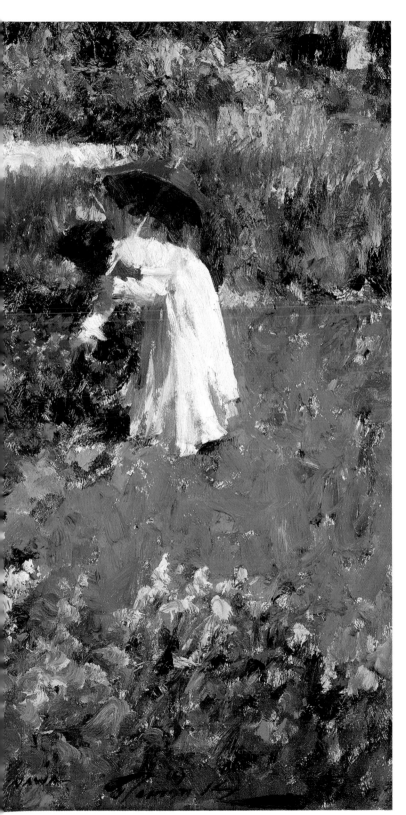

ESSENTIAL #3
Color

The key to beautiful, natural-looking color is contrast. Balance pure, intense colors with grayed-down neutrals and keep warm colors in check with cooler temperatures.

ESSENTIAL #4
Texture

Texture not only describes your subject, it adds greater interest to a painting. Incorporate the texture of your surface and create even more texture by varying the way you apply your medium.

ESSENTIAL #5
Focal Point

Work out which area of your painting will be the focal point. Then you can use the other essentials — Shape, Value, Color and Texture — to make it stand out.

I dedicate this book to my wife, Mona.

Introduction

When people walk into a gallery or museum, they have a lot of great works of art to choose to look at. But I'll be honest — I want them to look at my art! After all, that's my job. As an artist, I believe I'm also an entertainer. But that means I have to create art that will grab a viewer's attention long enough to let them explore it and have some kind of reaction to it, good or bad.

So I've asked myself many times, What makes someone stop and take a closer look at a painting? For me, a great painting has presence, a presence so powerful that I can't walk away from it. That's what I strive for in my work. I don't try to paint traditional academic paintings, but I don't want to look like all the other contemporary artists either, no matter how good they are. I want my art to stand out from the crowd. My continuing goal is to make paintings that are dramatic and intriguing, a unique expression of me.

If you want to make powerful paintings too, this book is for you. Now, I can't give you specific directions about how to express yourself through your art. But you wouldn't want me to tell you exactly what to do anyway. I can, however, show and tell you how I've

reached this goal in my own work and suggest how you can reach it in yours. It's like my friend says when I ask her for directions to a place: "I can't direct you, but I can show you how to get there". That's why I've written this book. Are you willing to follow me?

If you are, you're about to learn the five essential concepts that guarantee dramatic, unique paintings. I'll tell you right now, painting is not easy. And there are so many ideas and concepts and theories out there that make it even more complicated than it has to be. I've been through them all, read everything and studied as much as I can. But out of all the things I've learned, I've finally boiled it down to five fundamentals: composition, value, color, texture and focal point. I like to keep things simple, and I promise you that these concepts are all I need — and all you'll ever need — to create paintings with presence.

Mastering these five concepts is a bit like being a toddler. You have to learn to crawl before you can walk, and walk before you can run. You have to learn to use your voice before you can make words and then sentences. But eventually, you put all the actions together. It'll be the same with learning to paint. And once you put these

essentials together, there will be no stopping you! You may not be successful in every single painting — I still have flops and failures — but for the most part, you'll be soaring, you'll be flying! And you'll soon find that viewers won't be able to look away from your paintings.

The best thing about these concepts, in my opinion, is that there is an infinite variety of ways to use and interpret them. This means that even after you get comfortable with the concepts, you'll still be able to challenge yourself with new levels of sophistication in composing your subjects and using value, color and texture to bring out your focal point. Great! We'll never fall into the rut of sameness.

I now invite you to study my five essential concepts that provide the foundation for my paintings. As you'll discover, I haven't loaded this book up with lots of words to read. Instead, I'm going to teach you in picture after picture, as well as diagrams and demonstrations, how I think and how I paint. Are you ready to start making powerful paintings that have undeniable presence? Let me show you how to get there.

— Ramon Kelley

"FLORAL EXPLOSION"
PASTEL, 29¹/₂ x 21¹/₂" (75 x 55cm)

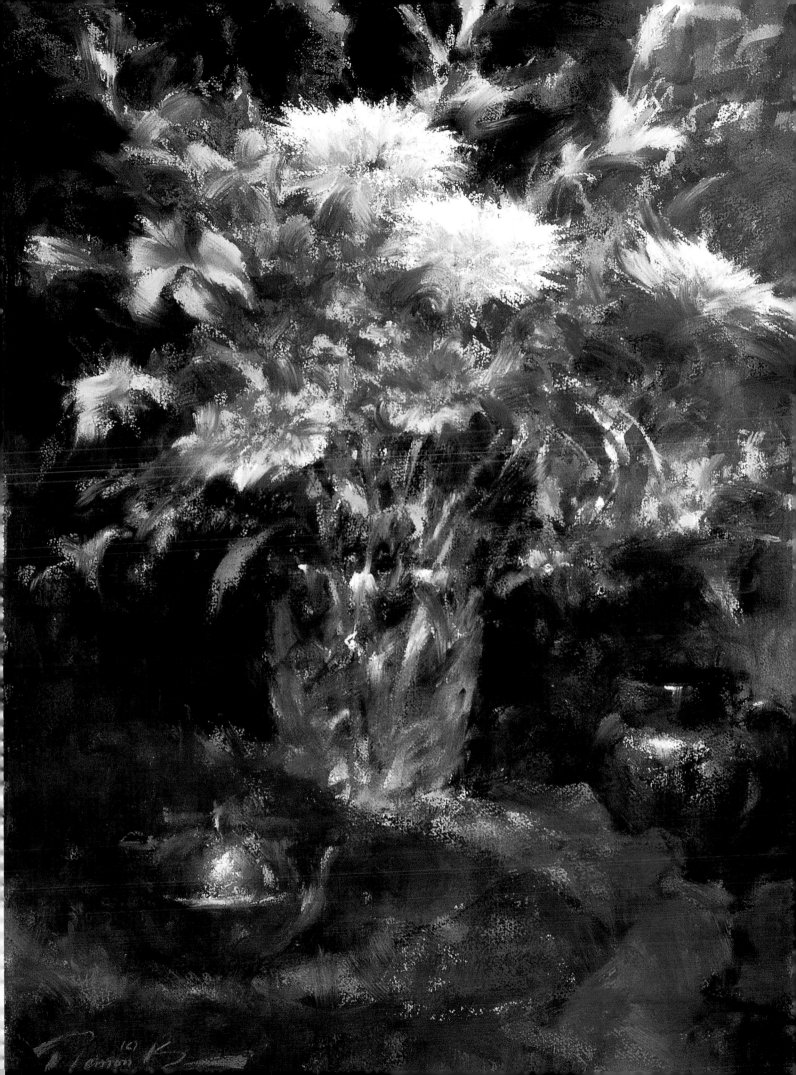

POWERFUL PAINTING
with Composition

Don't let the word "composition" intimidate you. A powerful, attention-getting composition is easy to achieve when you follow my three keys to organizing shapes.

When I first started my art career, I just painted faces. That's all I knew how to do. Then a wise old artist whom I really respected told me I needed to compose my paintings. I wasn't even sure what that meant! But I immediately set out to learn all I could about composition by reading books and studying the great masters.

What I found was a lot of rules and theories and terms that didn't agree or just didn't make sense to me. I eventually realized that there aren't any hard-and-fast rules about composition, but there are some simple guidelines to follow. Now I focus on three essential concepts when I compose a painting: direction, balance and integration. The resulting composition provides the foundational structure behind every powerful painting.

Understanding shapes — the main ingredient

A painting obviously needs to have more than one thing in it or it will be boring. But as soon as I start dealing with more than one thing, I have to start thinking about how the shapes of those things work together. This is all composition means — an awareness of whether the shapes are interacting to create an eye-catching, enjoyable, interesting picture.

To learn to compose paintings, I began by training my eye to group all of the different elements or objects in a scene into several — usually three to five — big, dynamic shapes. A shape is not an individual object; a shape consists of a group of objects or parts of objects that all have the same general value. Given this definition of a shape, it's easy to understand how one object can actually be part of two different shapes — its lit side will be part of a light-valued shape and its shadowed side will be part of a dark-valued shape.

I can easily see these big shapes when I squint down on the subject. But if I squint down and see too many shapes — for example, there are too many contrasts of light and dark passages — I know I need to modify the values of some small areas until I've linked them together and simplified the number of shapes.

LINKING WITH VALUE

In a good composition, the passages of light values and dark values create a unifying structure where none of the objects or elements are divorced from each other. Look at **"Brass Pot and Onions", oil, 20 x 24" (51 x 61cm)** to understand this concept. Notice how all of the red onions connect with each other and with the dark background. In the same way, the yellow onions connect with each other and with the light foreground. Through value, all of the shapes within the composition are integrated.

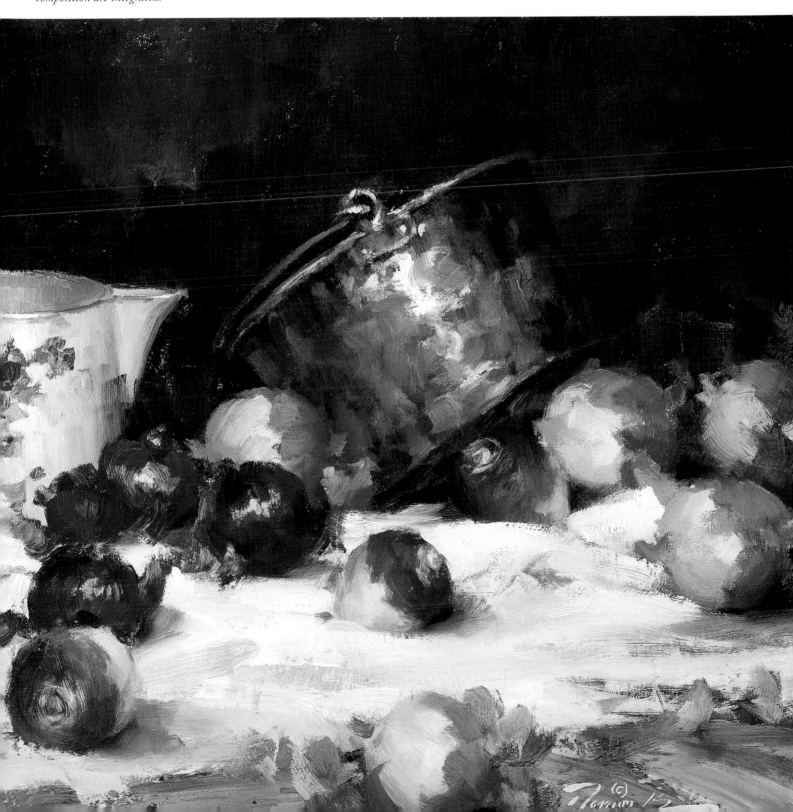

ORGANIZING BIG SHAPES INTO A STRUCTURE

When I look at any scene or subject, I squint down on it so I can see and simplify all of the different elements into maybe four or five very large shapes. Visually linking everything into just a few value shapes gives me a structure to hang my picture on. It seems that most of my paintings fall into a few basic arrangements of shapes, or structures, that have direction, balance and integration:

Many portraits and seated or standing figures naturally fall into a triangular structure. This large shape should then be divided up for greater interest, either with more shapes, color variations, lines, value changes or texture.

An angled edge, or even a suggested diagonal within a shape, is a great way to bring movement to a painting. However, it needs to be visually stopped with an intersecting horizon or some other large shape, or both, which creates a "V".

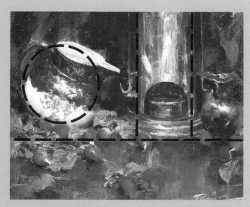

When most of the shapes within a subject are moving in the same direction, it's best to offset them with a different kind of shape in the opposite direction. This generally results in a "T" of shapes.

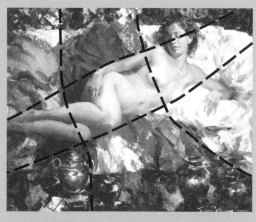

A variation of the "T" composition, the "H" is simply several bands of shapes moving in the same direction intersected by an opposing band.

Arranging the shapes

Once I can see the big shapes in my subject, I can then arrange and re-arrange them. The arrangement of big shapes provides a structure for the painting, and that's the most important thing. A painting must have a clear, organized structure to hold the viewer's attention.

When I'm painting still lifes, figures or portraits, I have total control over the arrangement of the big shapes, although it can still be a challenge at times. It's a little tougher with landscapes, but even then I can alter the objects and shapes to improve the picture. In general, I typically arrange my shapes into one of four basic, simple structures: a "T" formation, an "H" formation, a triangle or a "V" formation. Of course, these aren't the only options on the market. I'm always experimenting with new ways to arrange big shapes into dramatic,

exciting structures.

However, whether I use one of my four basic structures or something else, I always make sure my structure — the overall arrangement of shapes — has three essential qualities: direction, balance and integration. These are the qualities that make my compositions interesting to viewers.

Direction: Although I try to make my shapes unusual and dynamic in the

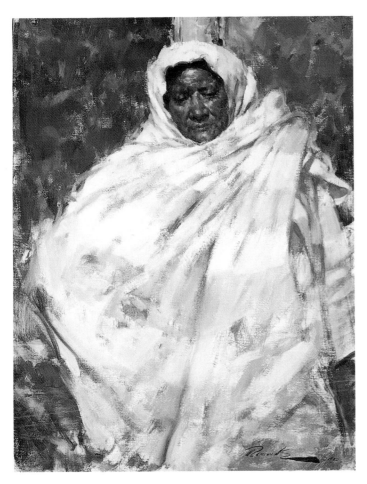

ACCEPTING A CHALLENGE

A composition and subject like the one in **"Pueblo Indian", oil, 24 x 18" (61 x 46cm)** *is a fun challenge to work with. I wanted the body to read as one big shape within the overall frame, but I had to make it interesting. How did I do it? I made sure the negative shapes of the background were interesting and different from one another. Then I broke up the white poncho with smaller suggested lines, shapes and textures to create movement and balance, although this still reads as one big shape from a distance.*

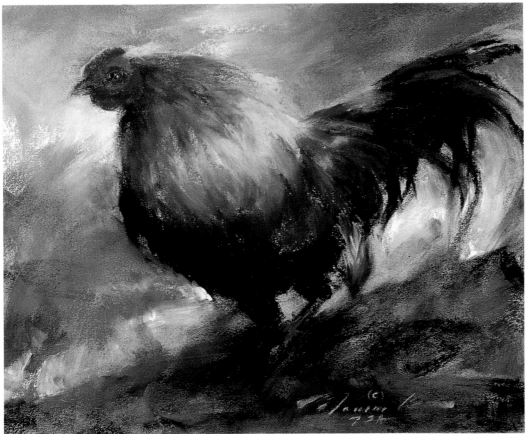

MOVING WITH COLOR

Color plays a very important part in directing your eye around the shapes within **"The Boss", pastel, 11 x 14" (28 x 36cm)**, *which won the Virginia M Ward Memorial Award from the Pastel Society of America. The unusual shape and bright red color of the comb attracts your eye first, then you move over to the next brightest object, the blue in the tail feathers. From there, your eyes swing down to the legs and belly and back up to the head. Notice how the tilted horizon line contributes to that eye movement.*

DIRECTING WITH SHAPE

While the larger shapes provide an overall structure for a painting, it's the smaller shapes within the big shapes that should lead your eye into the focal point. Look at these two examples to understand how crucial small shapes are in directing your eyes around a painting.

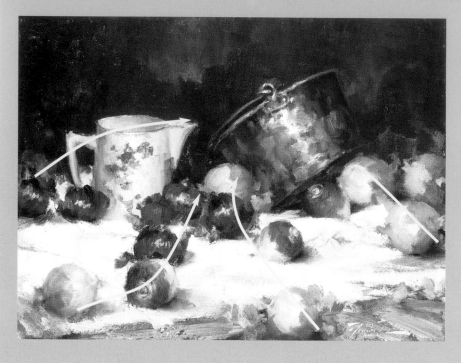 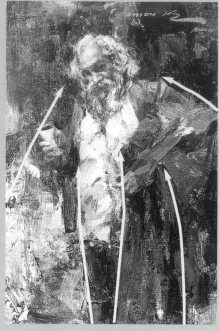

final painting, I begin by characterizing almost every shape as a simple circle, oval, square or triangle. Each of these basic shapes can have a direction, and it's important to study the direction of the shapes for two reasons. First, the shapes should be oriented so they point or direct the eye toward the focal point (see Essential #5) and not out of the picture. Second, the direction of the shapes must have contrast. For instance, if most shapes are running horizontally, there needs to be at least one vertical shape for variety.

Balance: Shapes also have weight, so heavy shapes need to be balanced with lighter shapes. A shape can look heavy because it is very large, very dark, very busy or very bright. It's good to take note of what's happening with each shape's weight early on so that other shapes with the opposite characteristics can be positioned for balance.

I particularly enjoy the challenge of working with balance. Deliberately setting up problems in this area allows me to find unusual solutions that make my paintings stand out in a crowd. For example, one of my favorite approaches to a landscape is to position the horizon line very high. This causes tension because it condenses most of the action into the small shape at the top of the canvas. I then have to put in a huge foreground shape for balance, and I enjoy the challenge of making that big, empty shape interesting without breaking it up.

Integration: Finally, no one shape should become an orphan, separated from the rest of the painting. Through value and color transitions, each shape should lead into the next so that there's a flow to the structure.

Integration is also important within shapes. There may be five — even 50! — different objects in an area, but they can appear to be one shape if they're integrated through value and color.

Having more objects makes a painting more interesting, but the objects must be integrated and simplified into those big, structural shapes. Otherwise, the painting can look too busy.

Getting off to a good start
Composition is where a painting begins. It can also be where a painting ends. As I often tell my students, "What you see is what you get", so make sure the shapes are directed, balanced and integrated before you continue. No amount of great painting in the later stages can disguise a poor composition.

But at the same time, keep your approach to composition simple. You don't have to have a revolutionary arrangement of shapes to hold your viewer's attention. A few basic, dynamic shapes will do. Then you can focus on making the painting even more exciting through your application of essential values, colors and textures.

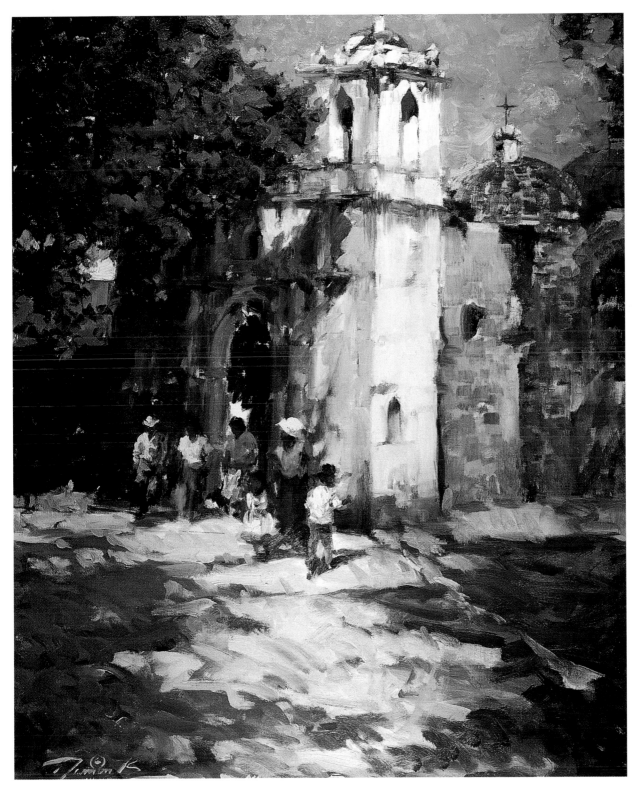

ADJUSTING BY EYE

*The value shapes in **"Old Mexican Mission", oil, 30 x 24" (76 x 61cm)**, especially the light and dark shapes in the foreground, are very effective in leading your eye into this painting. I actually think the composition is slightly heavy on the left because of that dark tree mass, but that's okay. As viewers, our eyes have a tendency to adjust to something that's slightly off-balance until we've "made it right" in our own minds.*

6+7½

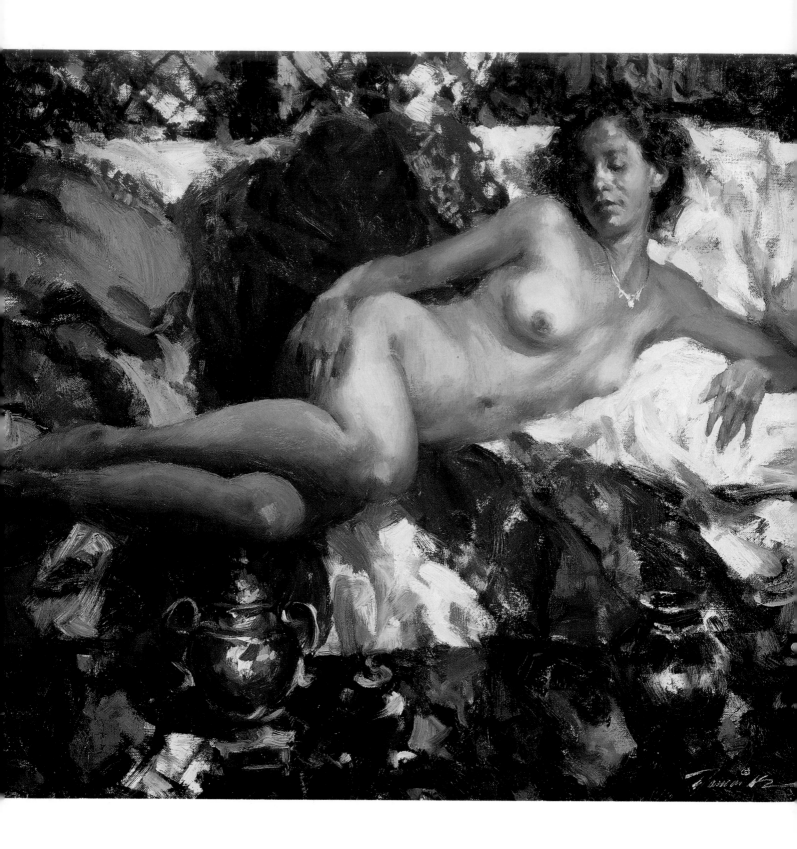

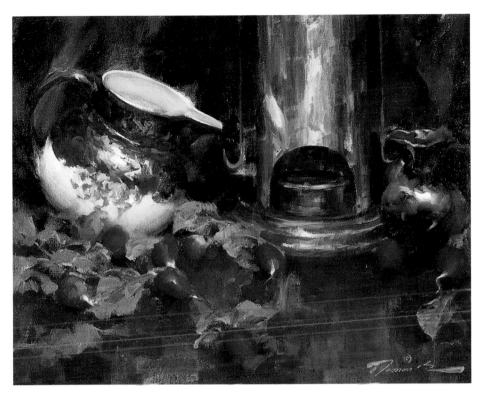

EMBRACING THE IDEALS

"Samovar and Pitcher", oil, 16 x 20" (41 x 51cm) exhibits many essential qualities of a strong composition. I deliberately chose a number of round objects in varying sizes, then added a tall vertical object for contrast and balance. I placed the objects in a way that gave the larger shapes some direction. Then, in painting the picture, I integrated these small shapes into bigger shapes through value, which provides a solid structure for the composition.

GETTING THE SET-UP RIGHT

A strong horizontal object like the reclining figure in "Midday Reflections", oil, 18 x 22¼" (46 x 57cm) requires contrasting directional shapes around it. That's why I placed different drapes behind her so that they'd create three vertical bands of middle, dark and light values in the background. The small, subdued vertical objects in the foreground also help to gently break up the dominating horizontal elements. I worked all of this out in my set-up stage so that the composition would be strong and interesting right from the start, before I laid down my first stroke of paint.

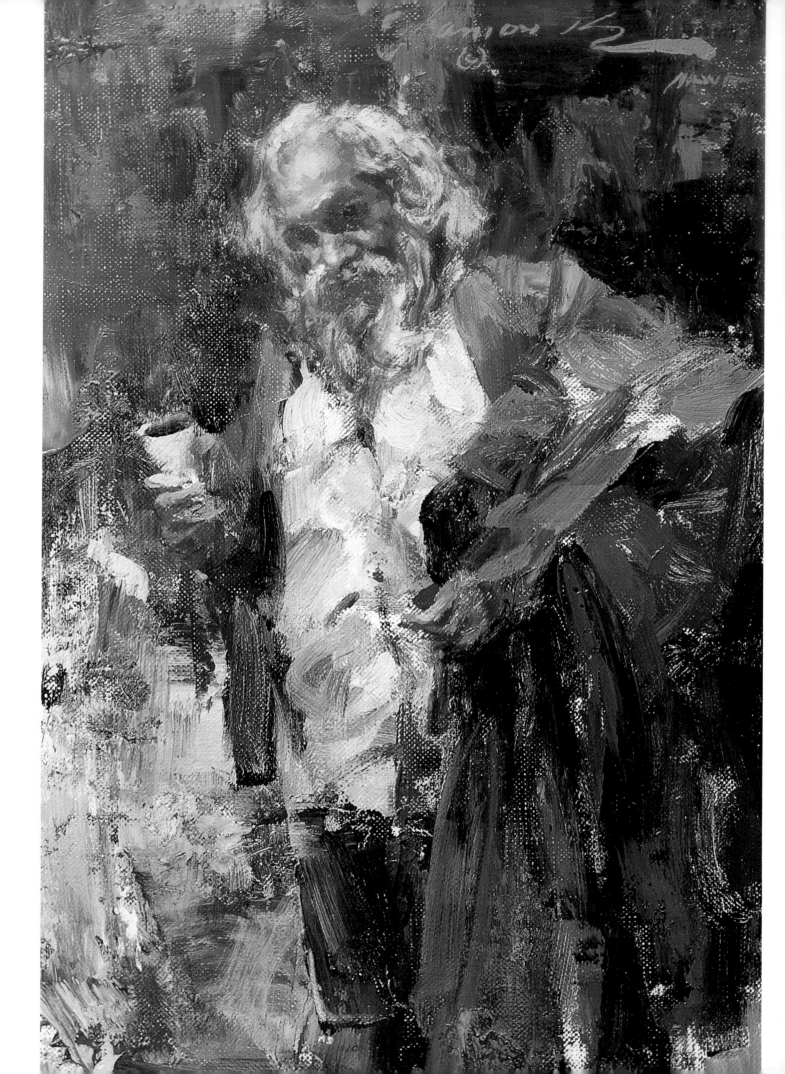

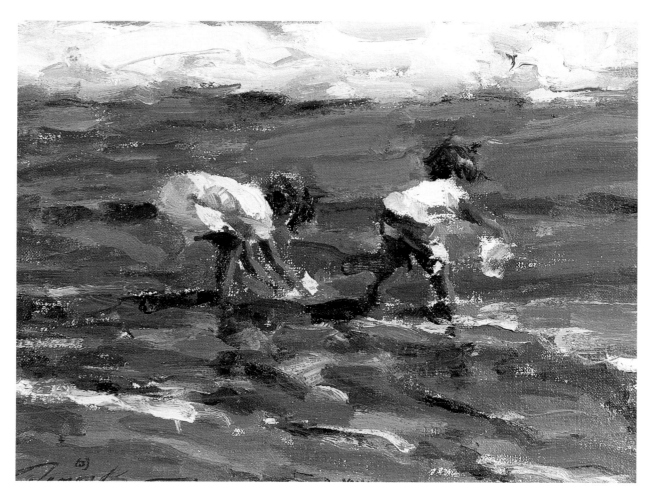

DOING IT MY OWN WAY

In **"Beach Buckets", oil, 9 x 12" (23 x 31cm)**, *I put the two active figures — the focal point — right in the middle, which grabs your attention because it's unusual. To keep the shape of these little figures from becoming isolated, however, I used white to visually connect and integrate this shape with two horizontal bands across the top and bottom. Together, they create a sideways "H" of shapes that ties the whole painting together.*

(LEFT) SEEING VALUES AS SHAPES

Studying this painting, **"Street Prophet", oil, 16 x 11" (41 x 28cm)**, *is a good way to understand what I mean by simplifying shapes. To my eye, there are four shapes in this painting. The light values of the head, hair, shirt and jacket unite these areas into one shape. Similarly, the darker values of his pants and the two items of clothing he's holding become one shape. That leaves the background, which I divided into two shapes — one light and one that moves from medium-dark to dark — for greater interest. These big shapes set you up for the small shape of the cup, which tells you so much about this person.*

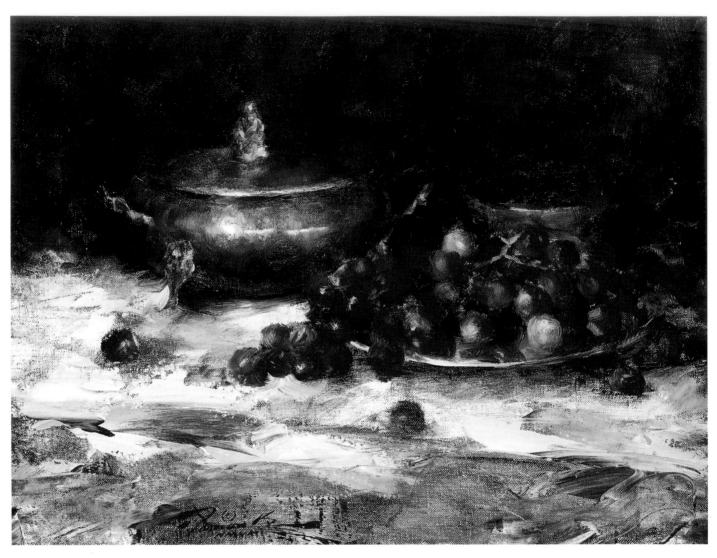

" . . . no one shape should become an orphan, separated from the rest of the painting."

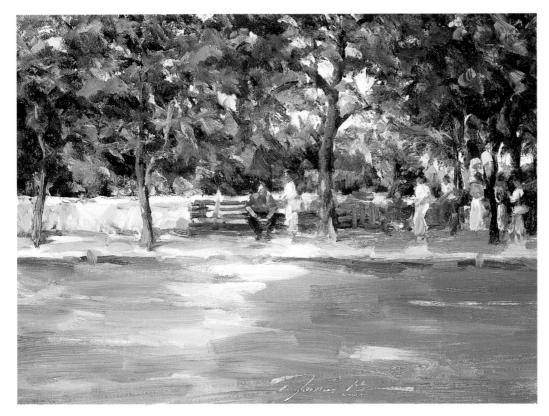

MAKING A DIFFERENCE

By paying attention to my shapes, I can take a simple subject and make it more exciting. Look at "Central Park, New York", oil, 14 x 18" (36 x 46cm), for example. This scene was essentially a series of horizontal rectangles, but I broke that up by creating an angled shape of light in the center of the street that leads into the figures at the bench, the focal point. This shape consists of all of about three strokes of paint, but it makes all the difference in this composition. It lets you stop and enjoy the activity and mood in the subject.

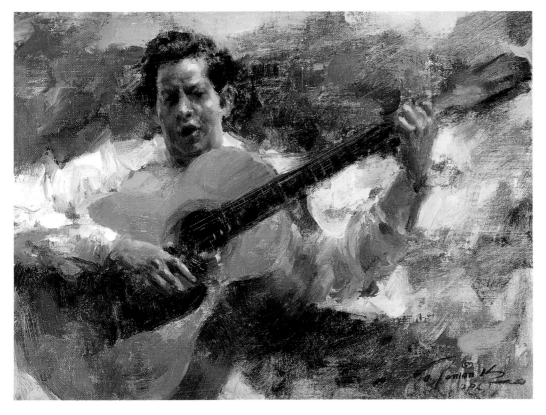

CAPTURING A SENSE OF MOVEMENT

Although this is meant to be a portrait of a guitarron player, a member of a mariachi band, I wanted the painting to have action, movement.

I started by dividing "Guitarron", oil, 12 x 16" (31 x 41cm) almost in half with the diagonal sweep of the guitarron's neck, and then used passages of light-valued shapes and dark-valued shapes to repeatedly lead your eye back to his face. The lively brushstrokes in this very direct, alla prima painting and the lack of detail also contribute to the spontaneous, active feel of the piece

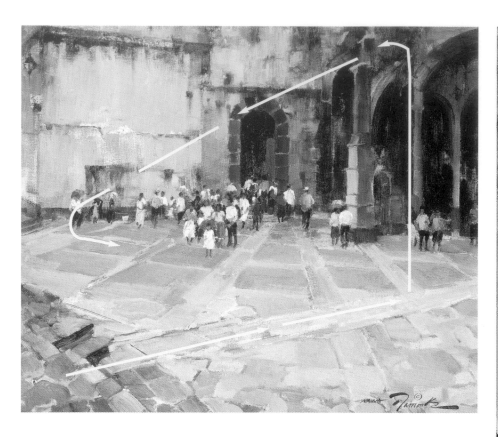

A WORD ON DRAWING

I can't emphasize enough how important it is to be able to draw well. If the perspective or proportions are wrong, it can ruin an otherwise great painting. Sometimes I can get away with inaccuracies in a landscape, or even in a still life, but it's absolutely essential to draw well in figure painting and portraiture.

To learn to draw well, I think it's vital to work from life and practice constantly. Trying to copy a photograph or projected image isn't good enough — only drawing from a real subject gives me the knowledge, understanding and experience I need. And even now, after many years of drawing practice, I still check the accuracy of my work in the early stages of every painting. I'll either turn my canvas upside down or check it in a mirror. Seeing it from a fresh perspective often makes mistakes jump out at me.

KEEPING IT SIMPLE

*If you squint your eyes, you'll see that **"The Church Cortez Built", oil, 18 x 24" (46 x 61cm)** really only has three shapes — it's very simple. What makes it so powerful is the force of direction of that angled line across the foreground. That sweeps you up into the darker upper right corner, where the arches then direct you over to the figures. This shows that a very simple composition can work as long as it keeps the viewer's eye moving within it.*

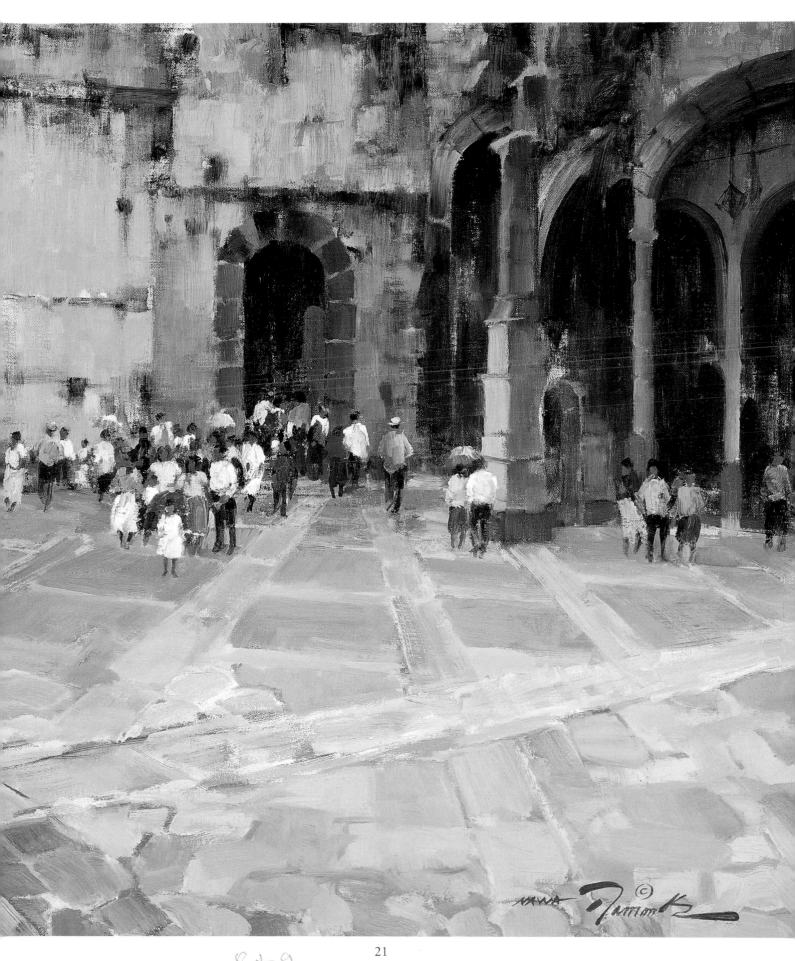

"The Lady of the Roses", oil, 20 x 16" (51 x 41cm) has an obvious religious theme, but I didn't really paint it with this purpose in mind. I was mostly concerned with setting up a good still life composition. I included the figurine because the tall, vertical rectangle contrasts nicely against the round shapes of the brass vase, oranges and roses. With all of this activity, you can see why I needed a spacious foreground for balance.

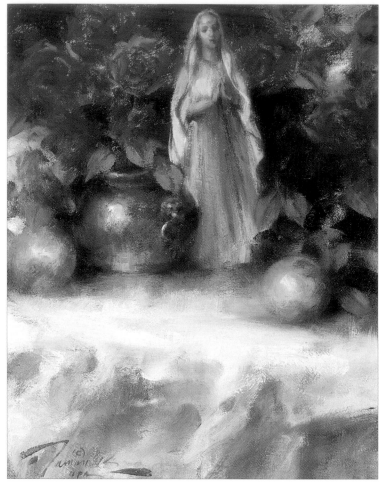

CUTTING LOOSE

When I'm painting on location, I often need to modify my subject a little to improve the design. But *"Mar de Mazatlan", oil, 9 x 12" (23 x 31cm)* was a ready-made composition just waiting to be painted. The beautiful curve of the shoreline as well as the horizon naturally lead into the distant spit of land covered with people, giving this painting an exciting directional attitude. Knowing that I already had a sound structure, I was able to "cut loose" and paint quickly and spontaneously, capturing all the activity and movement on the spot. This was a fun painting to do.

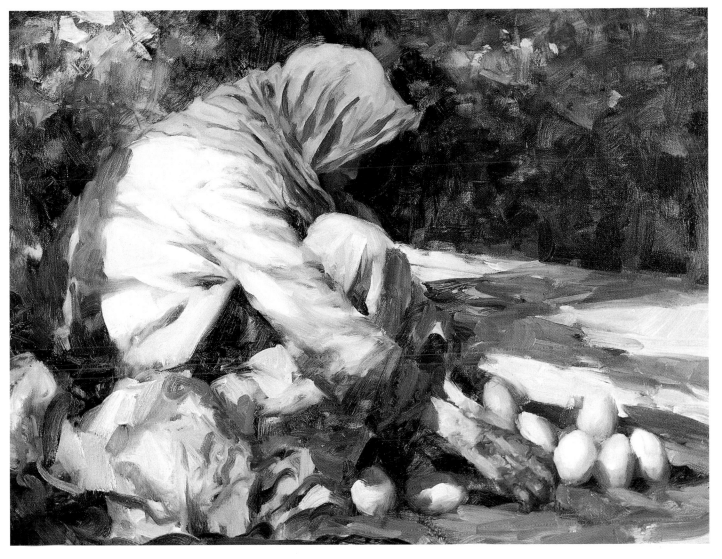

FINDING THE RIGHT PLACEMENT

*The placement of the figure was my biggest concern in **"The Egg Lady", oil, 18 x 24" (46 x 61cm)**. The shapes within the figure needed to both balance and lead to the eggs, which are the small focal point of the whole painting. I decided that pushing her crouching figure up against the left edge would provide the balance, and that extending her arm toward the eggs would give the directional movement I wanted. With so much riding on the placement of the shapes, I decided to roughly "draw" in the edges of my shapes with paint and brush first, rather than blocking in the generalized shapes as I usually do.*

> "You don't have to have a revolutionary arrangement
> of shapes to hold your viewer's interest."

USING TENSION TO ADVANTAGE

*I love to put a little tension in my paintings — it makes them so much more interesting for viewers. One of my favorite ways to accomplish this is by putting the horizon line up high, as I've done in **"Los Ornos del Pueblo", pastel, 19 x 25" (49 x 64cm)**, winner of the Pastel Society of America's Andrew Giffuni Award. Here, the unusually high horizon line forces most of the action to occur in the top third of the painting and means the tree has to be cropped off. This is the area of tension, but I've balanced it with a huge, calm expanse of foreground, broken up with a minimum of texture and repeated colors. Tension only works when it's balanced.*

(RIGHT) COMPOSING WITH A TWIST

*Portraits fall naturally into a triangular composition, but they can become far more interesting with an unusual pose or gesture. In **"Old Bobby", oil, 24 x 16" (61 x 41cm)**, I positioned him at an angle and asked him to drop his head and raise one arm. These shifts broke up the now lop-sided triangle into more exciting shapes. Note, however, that all of the shapes are still positioned to lead your eye back into the focal point.*

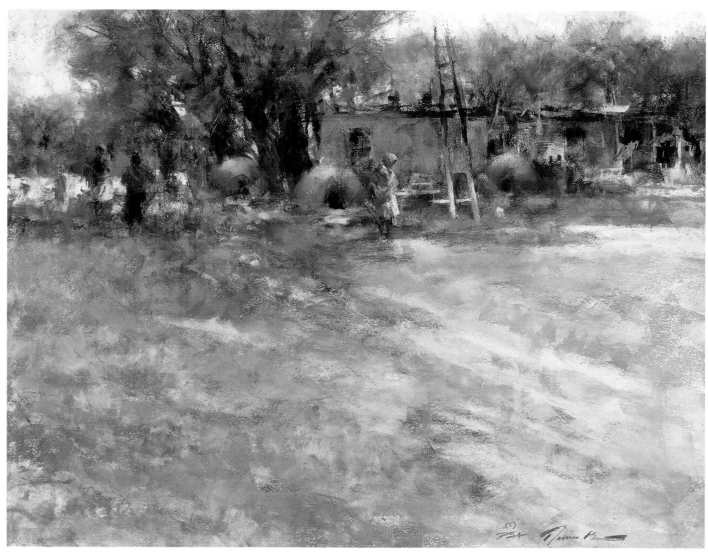

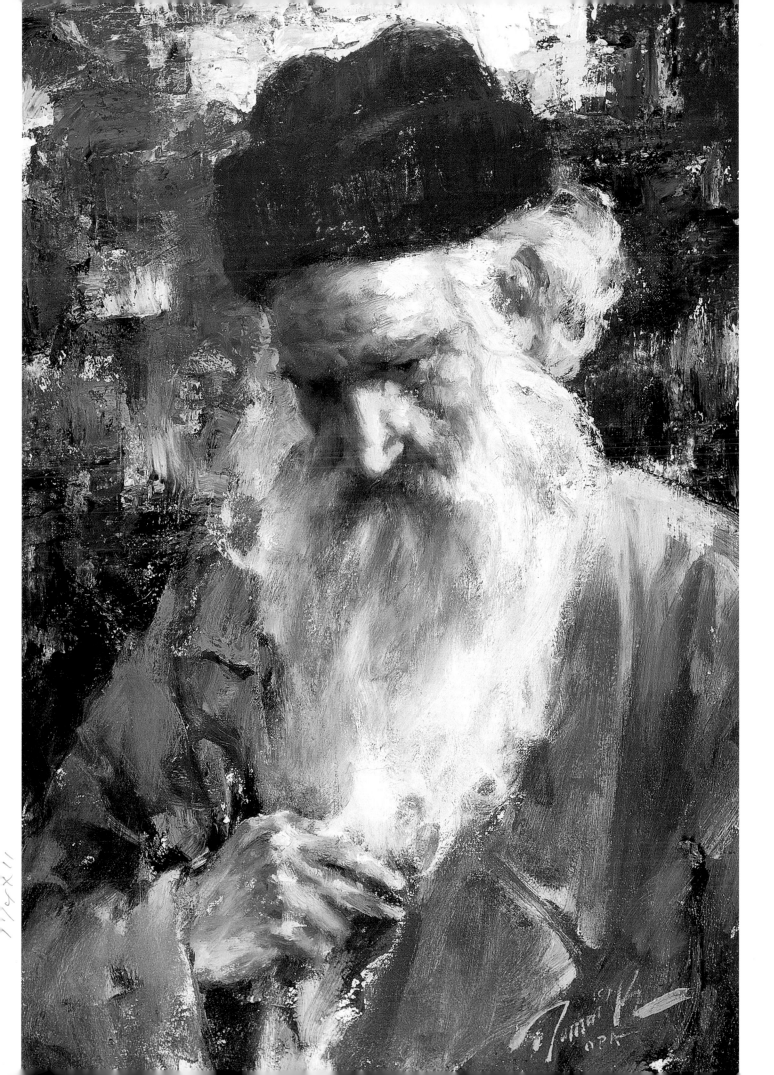

I have learned more about the craft of painting from still lifes than from any other subject matter. It's a great way to learn to paint the four most common shapes — circles, ovals, squares and triangles — which is knowledge that can later be applied to any subject, from portraits to landscapes. Still lifes are also perfect for learning to work with colors, temperatures, values and especially composition.

This particular painting has many of the qualities I like in a still life. There are a lot of objects providing a lot of color and activity, but the larger integrated shapes and values within the composition keep it from falling apart. I also like the way the flowers break out of the top of the picture. To me, this looks far more interesting than a small cluster of objects floating within the canvas.

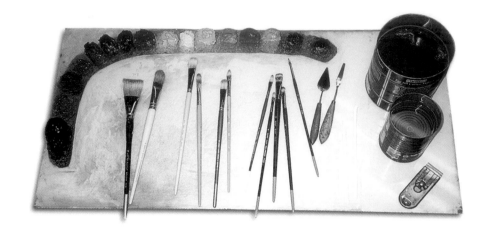

WHAT THE ARTIST USED

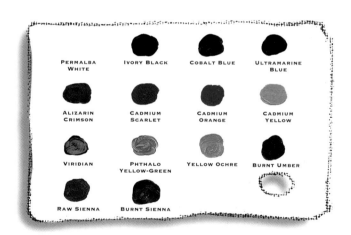

SURFACE
Oil-primed Belgian linen

OIL PAINTS
Permalba White	*Cadmium Yellow*
Ivory Black	*Viridian*
Cobalt Blue	*Phthalo Yellow-Green*
Ultramarine Blue	*Yellow Ochre*
Alizarin Crimson	*Burnt Umber*
Cadmium Scarlet	*Raw Sienna*
Cadmium Orange	*Burnt Sienna*

BRUSHES
Filbert and flats in several sizes (bristle brushes to start with and red sable or mongoose hairs in later stages)

PALETTE KNIFE

LAYING IN LIKE VALUES

I began by arranging my objects on a table in my studio. Originally, I placed just two oranges to the left of the vase, but this made the vase and flowers look too heavy. I added the two oranges on the right for balance. Then I moved a spotlight fitted with a north-light bulb around the arrangement until I found a direction that was especially interesting.

Using a No. 8 filbert, I began by blocking in the medium value of the main color shapes in Cadmium Orange, Cobalt Blue, Cadmium Red, Viridian and Burnt Umber. However, I kept my overall structure of value shapes in mind as I did this. I saw the larger shapes in this composition forming an "H" on its side. In other words, while blocking in my colors, I made sure I had two horizontal bands of like values running across the top and bottom connected by a band of mid-tones.

BREAKING UP THE LARGER SHAPES

Continuing with the same basic lean colors, I worked all over the canvas to refine the overall pattern of light and dark values. I also started to put a little "stuff" in the big shapes, meaning I began breaking up the larger value shapes with smaller objects. But notice how I kept using the same values for the stuff within each large shape. I also started to integrate shapes by putting the darker shadow values in some objects, such as the oranges.

REFINING THE FOCAL AREA

At this point, my composition of big value shapes was pretty well established so I could start refining the image, especially in and around my focal point. Using a No. 12 flat bristle, I added heavier, fatter strokes of paint to the flowers, vase and oranges, while leaving the shadow sides lean. I love working in color!

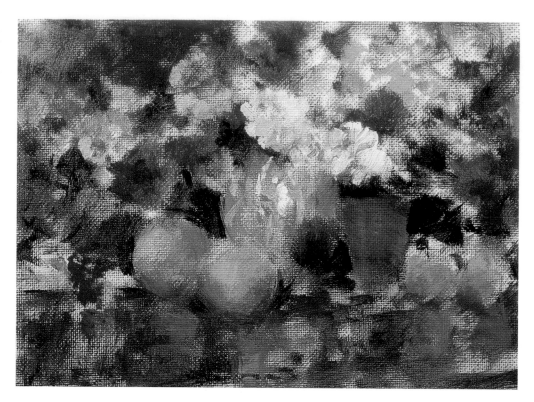

ADDING LIGHTER VALUES

Here, the painting started to come alive as I added the lighter values and accents to each large shape in the entire composition. Since the mass of flowers and the oranges are already light in value, I brought in even lighter values there. However, the lighter areas added to the blue cup and the table top are actually quite dark in value, just lighter than what was already there.

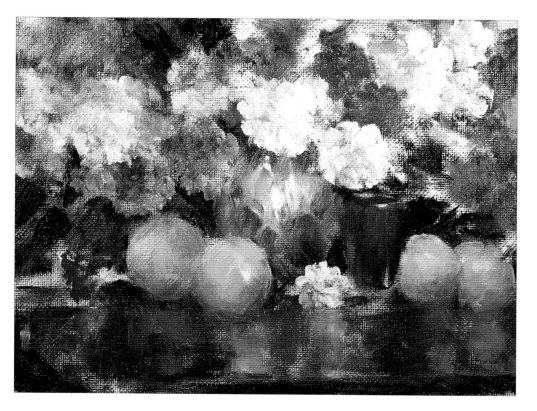

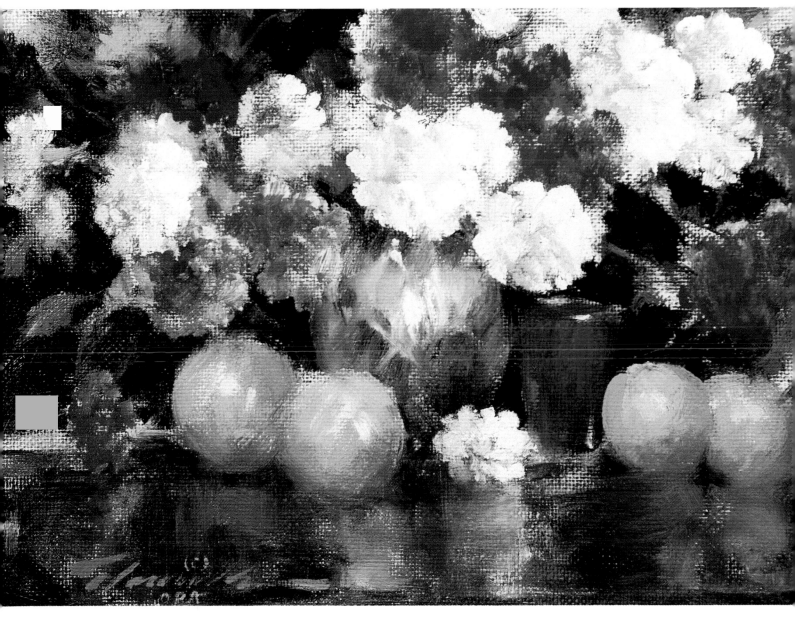

BALANCING WITH COLOR

*In my final pass over **"Still Life with Oranges", oil, 9 x 12" (23 x 31cm)**, I used accents of color to unify the composition. The darkest shapes across the background created a chiaroscuro effect, as if pushing the light objects out of the darker background. I then intensified the four red flowers across the top and added that extra note of yellow-orange in a fifth flower to balance the oranges. Without the rich colors of these flowers, the brightness of the oranges would have isolated them like four little orphans and trapped your eye in this one small passage. Through color, as well as value, I created an integrated, balanced composition.*

The 4 other ESSENTIALS

Value

Large shapes of like values create a structure for this painting in the form of an "H" on its side. There's a horizontal band of light values across the top, a horizontal band of dark values across the bottom and a vertical band of mid-tones that connects them.

Color

This painting is dominated by many bright, warm colors, but two things keep it from getting out of control. One is that the warms are balanced by plenty of cools in the background. The other is that the most intense colors — the oranges — are offset by slightly less intense colors in the highest flowers. Imagine how overpowering the oranges would have been without these warm, bright accents.

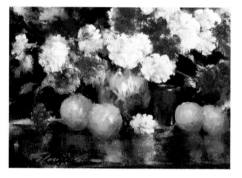

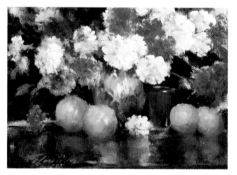

Texture

With so many smooth textures in the vase, cup and table top, I didn't want to have incongruously rough textures in the flowers and oranges. Notice how they are painted with a little less texture than I could have used.

Focal point

The oranges are the most brilliant objects in the painting, so they grab your attention first. But with two pairs of oranges, I had to do something to make one pair more dominant, more obviously the focal point. To do this, I made the pair on the left slightly larger and surrounded them with darker shapes, including the dark accents just below and to the sides. Note, however, that they have some soft edges to integrate them.

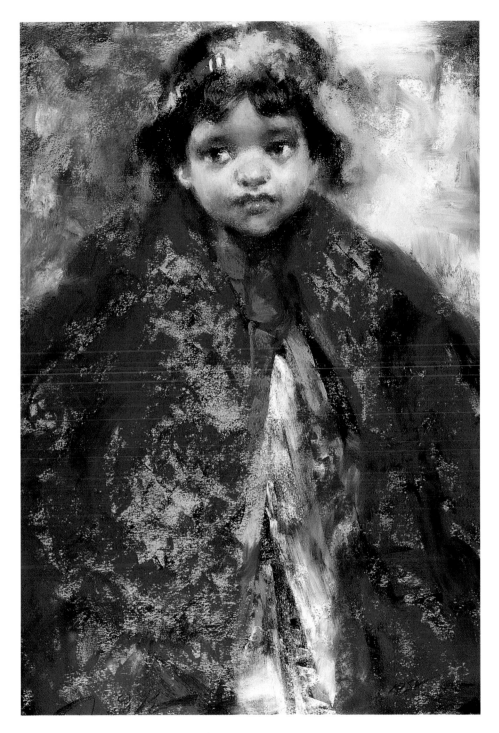

MAKING BIG SHAPES INTERESTING

"Little Indian Girl", pastel, 18 x 12" (46 x 31cm) is another example of a simple kind of composition — essentially, the head sits on top of a mountain of red. This approach works for two reasons. One is that all of the edges or "lines" in the shapes lead to the focal point. The other is that there is a lot of exciting "stuff" happening within the big shapes to keep it interesting. The repeated reds and oranges tie the whole painting together.

THE ESSENCE OF COMPOSITION

Dramatic compositions don't need to be complicated. In fact, simple is better, as long as the big shapes form a sound structure with these three qualities:

- **Direction** — a variety of shapes in opposing directions lead the eye to the focal point

- **Balance** — small, busy or dark shapes are balanced by large, calm or light shapes

- **Integration** — big shapes flow into one another while the "stuff" within each big shape is united by color and value.

POWERFUL PAINTING
with Value

This essential concept packs a double punch: You can learn to use value to create three-dimensional depth and to lock your viewers into your paintings.

Every artist knows that the word "value" refers to the lightness or darkness of a color within a painting. It seems so simple to understand, but it can be difficult to put into practice. In fact, I've seen many good paintings weakened by a poor use of values. That's why learning to use values to your advantage is so important.

The way I see it, there are two essential points within the concept of values to understand. One is how value can create the illusion of three dimensions by making objects and space visually recede. The other is how the overall pattern of values within a painting can direct your eye. Used effectively, values give a painting so much presence that viewers can't look away.

Relating light, value and form

Although my style is loose and impressionistic, I'm still a realist. I want my objects to be believable or at least fairly recognizable. So my challenge is to create the illusion of three-dimensional objects on a flat painting surface. I've found that value is my greatest ally in achieving this goal.

When I look at any object, my eyes can tell me whether the thing I'm looking at is flat or has depth. How do they do that? By registering changes in the relative lightness and darkness of each part of the object. If the color of the object remains the same, light is falling evenly across its surface so it must be flat. But if the color of the object varies, some parts are receiving more light than others so it must have form and depth.

This may seem obvious, but it's so important. If I can accurately see and then reproduce these variations in value on my surface, I can create the illusion of three dimensions.

Sculpting form from a flat surface

When I start a new painting, I begin by blocking in the whole simplified shape of an object in a single value of the

FOLLOWING THE PATH OF LIGHT

*Cutting through the very dark and fairly dark passages of **"The Swan Dancer"**, oil, 11 x 14" (28 x 36cm) is a swath of light coming from the upper left and continuing on the lower right in the white fabric. In my estimation, you can't get more dramatic than this. As always, when painting the white skirt, I initially painted it lower on the value scale, then brought up the lightest areas to give it more variety, which makes it more believable.*

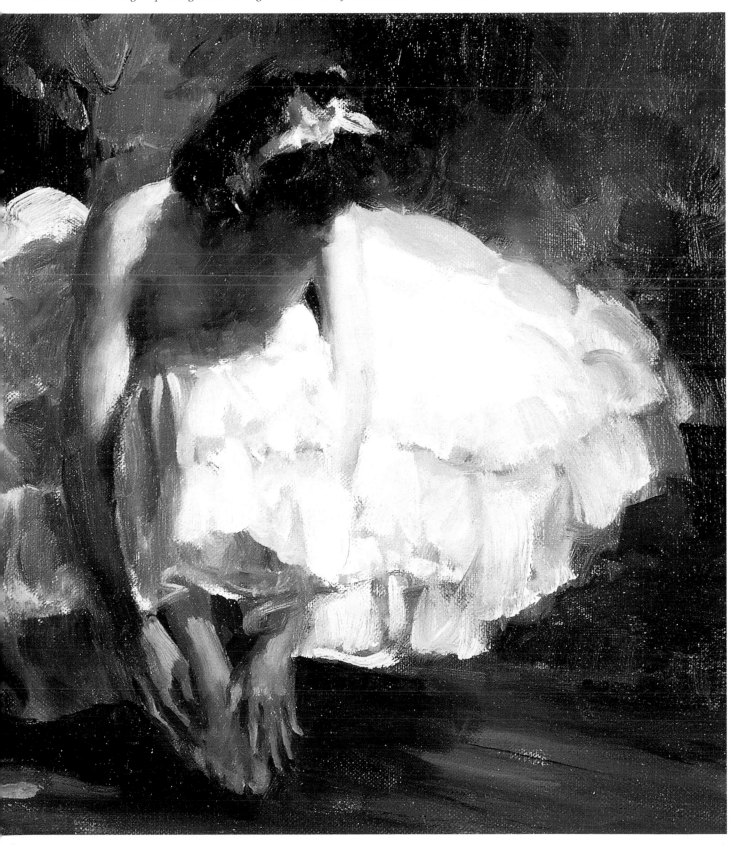

object's color. I choose a value that would fall in the middle of a nine-step scale of that color, with the first step being the lightest possible variation of the color and the last step being the pure color. For example, if I were painting a red apple, I'd block in the whole apple shape in a medium value of red. I'd then move to the outer edges of the object, where I'd place a darker value of the same color on the shadowed side and a lighter value of the same color on the side facing the light. I'd then use the lightest value of the color to put in a highlight, probably somewhere closer toward the center again, depending on the light source.

Does this approach sound simple? It is, now that I have the hang of it. To master this fundamental, I used to paint basic objects again and again so I could study how the value of an object changes with the light. At first, I used black and white paint only, and then I graduated to painting objects in color. Eventually, I taught myself to use a different value of a completely different color for my shadows and lights within an object, which gives my color scheme a bit more variety. I still recommend this invaluable exercise to my students today.

After a lot of practice on individual objects, I realized this concept works because the darker values visually recede or move back while the lighter values advance or come forward. I decided to apply this concept to whole paintings to give them tremendous depth. This is why I now routinely begin a painting by massing in all of my mid-tones throughout the entire painting, then put in all of my darks and finish with my lights. I don't blend or even try to make anything look three-dimensional until I have these three stages down because the illusion happens fairly naturally with this approach. Usually only a few adjustments and accents are needed at the end for greater depth.

One thing I've noticed about myself — not to mention many other artists —

LEARNING YOUR VALUES

Just like a musician, a painter needs to practice scales — value scales! Painting a nine-step value scale for each individual color on your palette is a great exercise for getting to know the full value potential of those colors.

On a surface, mark off nine small, 1-inch squares in a row. Then fill the first square with one of your colors straight from the tube. This is No. 9. Add a touch of white and fill in the next square, and continue to add white until you've painted nine patches with white as

No. 1. Or, if you'd prefer to keep things more simple, paint a five-step scale like the one used by John Singer Sargent.

Whether you paint in oil, watercolor, acrylic or some other wet media, I recommend painting a scale for every color on your palette. In the next section on color, I'll discuss the benefit of doing the same exercise with color combinations. Familiarizing yourself with your palette at this level makes it easier to mix the exact color and value you need.

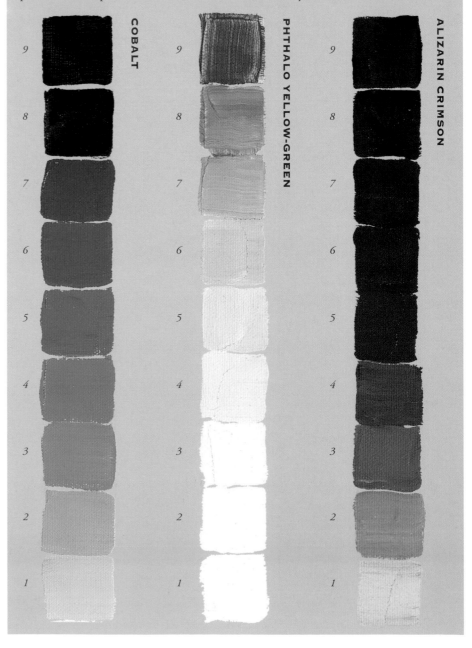

COBALT

PHTHALO YELLOW-GREEN

ALIZARIN CRIMSON

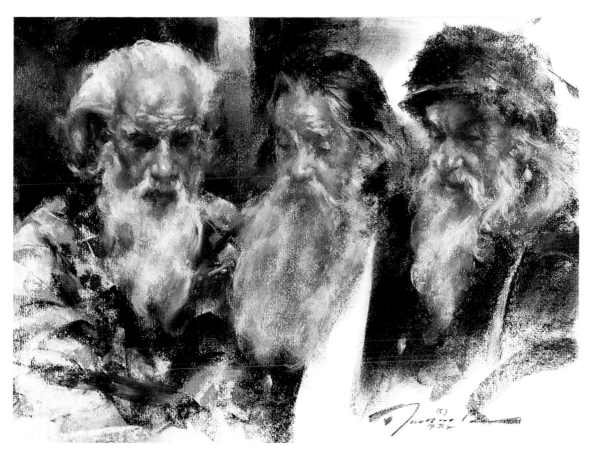

UNITING WITH VALUE

*Making three portraits in one, **"Luke, Old Gilbert and Pappy", pastel, 12 x 16" (31 x 41cm)** became quite a challenge in terms of value. Luke on the far left has many light values in his very definite white hair and beard, Old Gilbert is Hispanic so he's a little darker and Pappy was receiving more of the light but was wearing dark clothing. Notice how I used big shapes of value in the background to both accentuate and unite the triple portrait.*

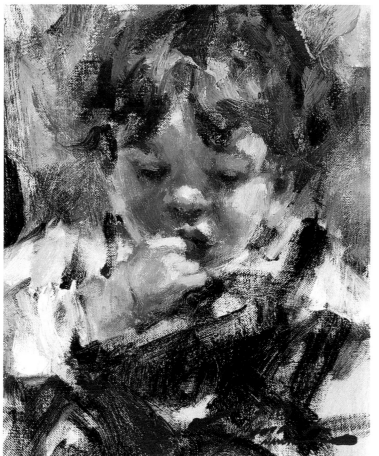

SHARPENING MY SKILLS

*At times, I find myself spending too much time on some small portion of a painting, such as a face or hand, and the results look overworked. To sharpen my senses, I challenge myself to create a work that looks as if the image was just "breathed" onto the canvas. I allow myself one hour to do a quick color study, such as **"Baby Study", oil, 10 x 8" (26 x 20cm)**. This type of exercise forces me to use value and color to make the painting read well, without including a lot of detail.*

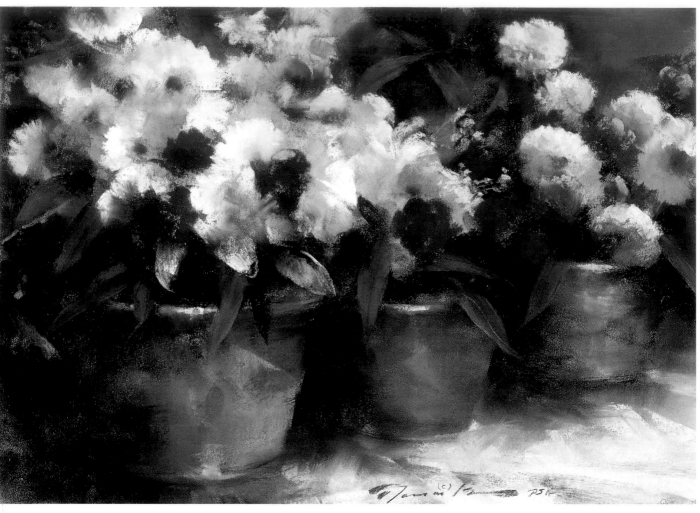

EASING THE TRANSITIONS

I used a full range of values from black to white in "Flower Buckets", pastel, 12 x 17" (31 x 44cm). Yet, there's nothing jarring or shocking about this painting. The values gradually change with careful transitions that gently lead your eye back into space and around the painting. Easy on the eye, the values contribute to the peaceful mood.

is that I tend to want to paint the lights first. But all those light lights in a painting become monotonous. That's why I consistently follow this process of painting the mid-tones first, then the darks and then the lights. And when I'm painting white or light-colored objects, I actually paint my preliminary values a little darker than what I see. With a firm foundation of darker values, I usually don't need as many light values as I thought, which makes the painting more exciting in the long run.

Designing with values

Once I had mastered the use of values to create depth, I started to put this concept together with the concept of shapes in a composition. So instead of painting the values of my objects exactly as they appeared, I began to modify the overall range of values for that object to

fit in with the design of my composition. For example, if I had placed an orange within a large shape that I wanted to remain dark, I would use a darker orange color — perhaps a 7 or 8 on my scale — as my "mid-tone", a black-orange for my shadow and an orange at a value of perhaps 6 on the scale for a light accent with no highlight. In this way, the orange still reads as a round, orange object but one that's sitting in shadow.

Modifying the values of objects to fit my overall pattern of value shapes became very exciting to me and has been the key to the drama in my paintings. You see, traditional academic painters say that you should limit the general range of values used in any painting to a maximum of four or five steps on the scale. I follow this approach sometimes when I want to make a quiet painting, but generally I prefer to design

CHOOSE THE RIGHT RANGE

Traditionalists say you should limit most of your values to a fairly small range and highlight the focal point with light and dark accents. This approach does work well for creating quiet, cohesive paintings, such as *"Thomas"* (mostly light values, or high key) and *"Oranges and Brass"* (mostly dark values, or low key). But when I want to create a very dramatic work, I use a full range of values from black to white, as I did in *"The Swan Dancer"*.

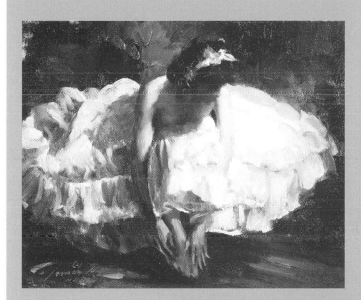

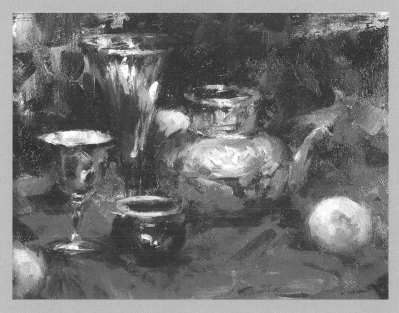

my compositions so they encompass a full range of values in my paintings.

To me, the most dramatic paintings that have the greatest impact on my viewers are those with a full range of values. I especially like to use the "chiaroscuro" effect — a light-valued image emerging from a dark background, like Rembrandt used. It's hard to do because I must take care to create gradual transitions from light to dark, otherwise the values will have too much contrast, which will shock the viewer.

But no matter whether I'm using a full range of values or a limited range of values, I always make sure that the lighter values visually "link together" to create a pathway of light leading to the focal point. By strategically placing shapes or even small accents of progressively lighter values, I can guide the viewer's eye right up to the focal point, which usually has the lightest values of all. In the same way, I can position darker shapes or accents that will push the eye away from an edge and steer it back into the action.

Playing two roles

Understanding values is not necessarily easy, but it can be done if you focus on mastering the two main uses of value — creating depth and leading the eye. I recommend painting simple objects over and over until you get the hang of accurately seeing and reproducing the values of your colors in a way that creates three-dimensional depth. Then you can get more sophisticated and start using and modifying your overall value patterns for greater dramatic effect in your compositions.

GOING TO EXTREMES

*With a Mexican-American subject like the one in **"Baby Girl"**, pastel over watercolor, 10 x 8" (26 x 20cm), a full range of values is needed to accommodate the black hair and olive skin. What keeps this composition from breaking up into extreme contrasts of value are the full range of transitional values that appear throughout the shadows in the face and into the background.*

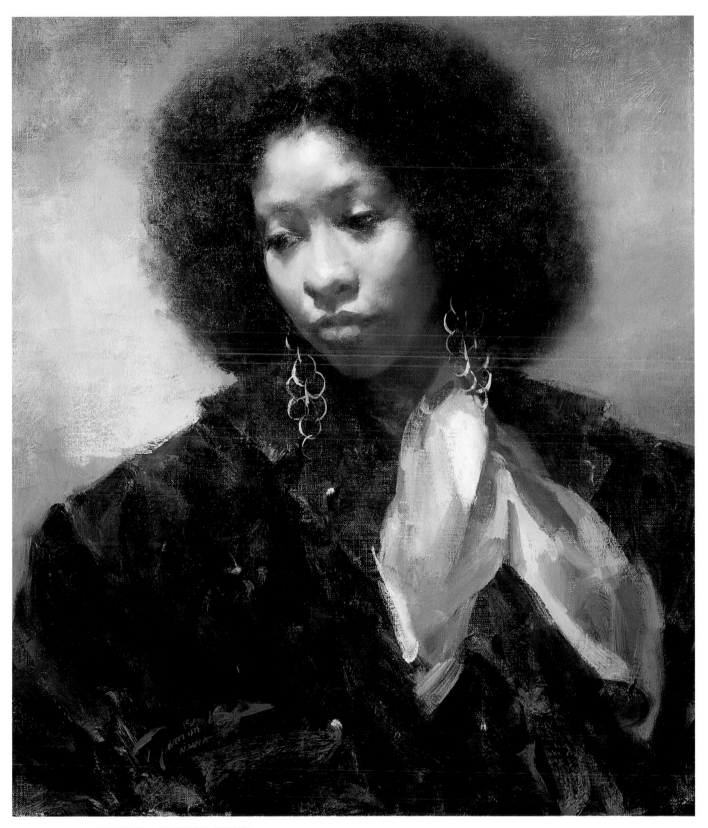

KEEPING THINGS QUIET

This beautiful part Puerto Rican, part African-American woman is a great model, but the dark values of her skin and hair present a challenge. In **"Nadine", oil, 24 x 18" (61 x 46cm)**, *I had to use very subtle value changes throughout her black hair to make the overall shape of her head look three-dimensional. To integrate this dark shape into the rest of the painting, I brought some of those same value tones down into the shadows in her face and surrounded her with darker values in her clothing and background.*

DEALING WITH BACKLIGHTING

*Backlighting, which I used in "**The Gardener**", oil, 18 x 24" (46 x 61cm), can be problematic but exciting. To make it believable, I had to really control and knock down the values in the figure and cast shadows in order to make the background seem lighter. But I still followed my usual stages — middle tones first, then darks, then light accents.*

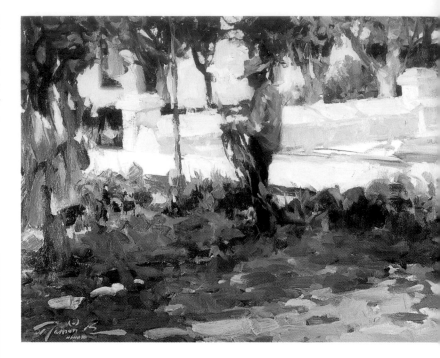

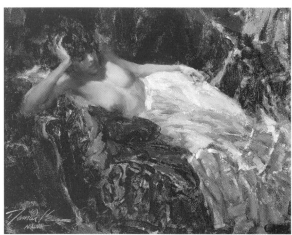

CIRCLING IN ON VALUES

*"**The Victorian Pose**", oil, 11 x 14" (28 x 36cm) shows just how effectively value can lead our eyes around a painting. We're initially drawn to the powerful focal point of the face, but then light values guide us to the breast, waist and hand before bringing us down and around the slip and legs. The medium value in the fainting couch completes the circle and returns us to the focal point.*

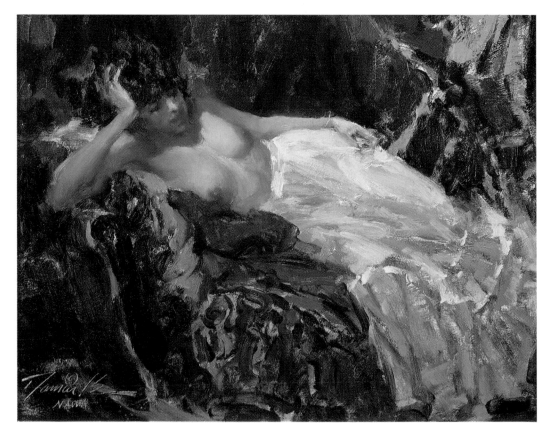

"I always make sure that the lighter values visually 'link together'
to create a pathway of light leading to the focal point."

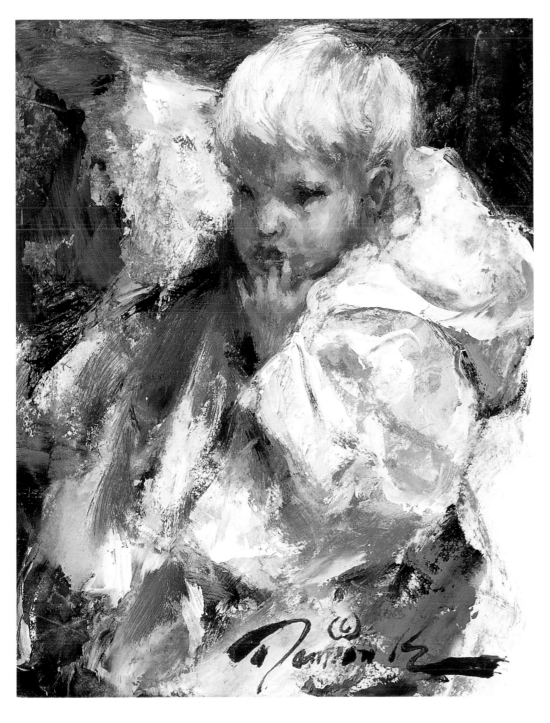

CREATING A MAP

Before I jump into a large-sized painting, I like to try ideas and work out my composition and resolve any problems in a small study. This saves a lot of time! For example, as I was working with this young model, I decided to paint all of the elements in a high key in the final portrait, so I mapped out my values in this study called **"Russian Boy", oil, 7½ x 6" (19 x 15cm).**

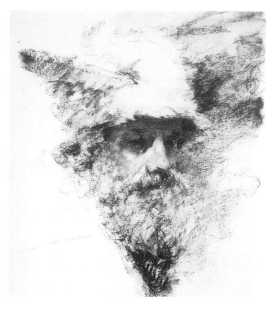

GETTING SOME PRACTICE

As opposed to line drawings, value drawings like **"Mountain Man", Conté crayon, 12 x 9"** *(31 x 23cm) and* **"Male Nude", Conté crayon, 16 x 12" (41 x 31cm)** *are great practice for learning to use value to create the illusion of three-dimensional objects on a flat surface. Done from life, value studies are also good exercise in drawing accurately and generating texture.*

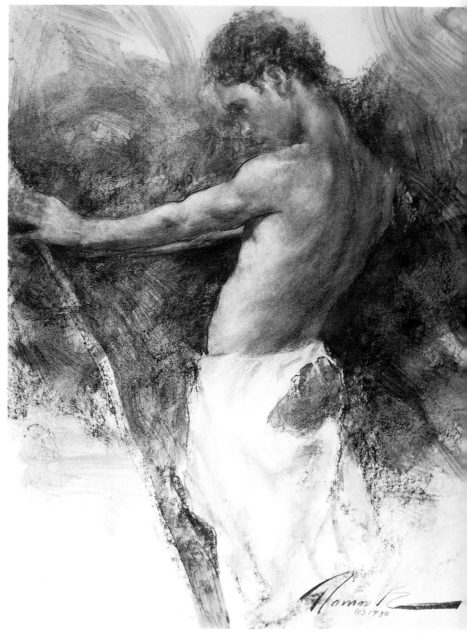

"Used effectively, value gives a painting so much presence that viewers can't look away."

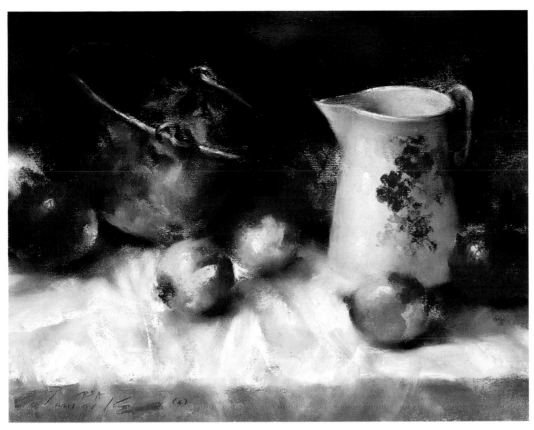

ROLLING WITH VALUE

*Although this painting is done loosely, the onions in **"Brass Pot with Red Onions"**, **pastel, 11 x 14" (28 x 36cm)** look so believable, it's as if they're going to roll right off the table into your lap! This is the power of using different colors in the correct values to give objects three-dimensional form. When it works, it really works.*

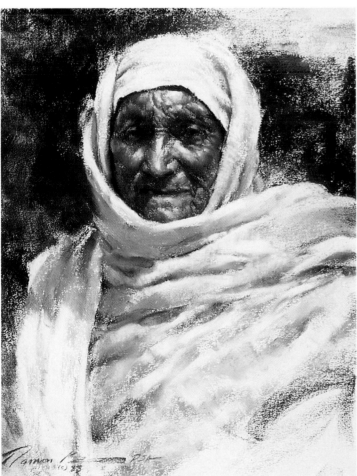

PUTTING IN DIMENSION

*In reality, this Taos Indian's skin color is monochromatic, but I used a full range of values, all the way from black to white, to paint his face. Not only did this make **"Mountain Go"**, **pastel, 24 x 18" (61 x 46cm)** more dramatic, it made the face more real, more three-dimensional.*

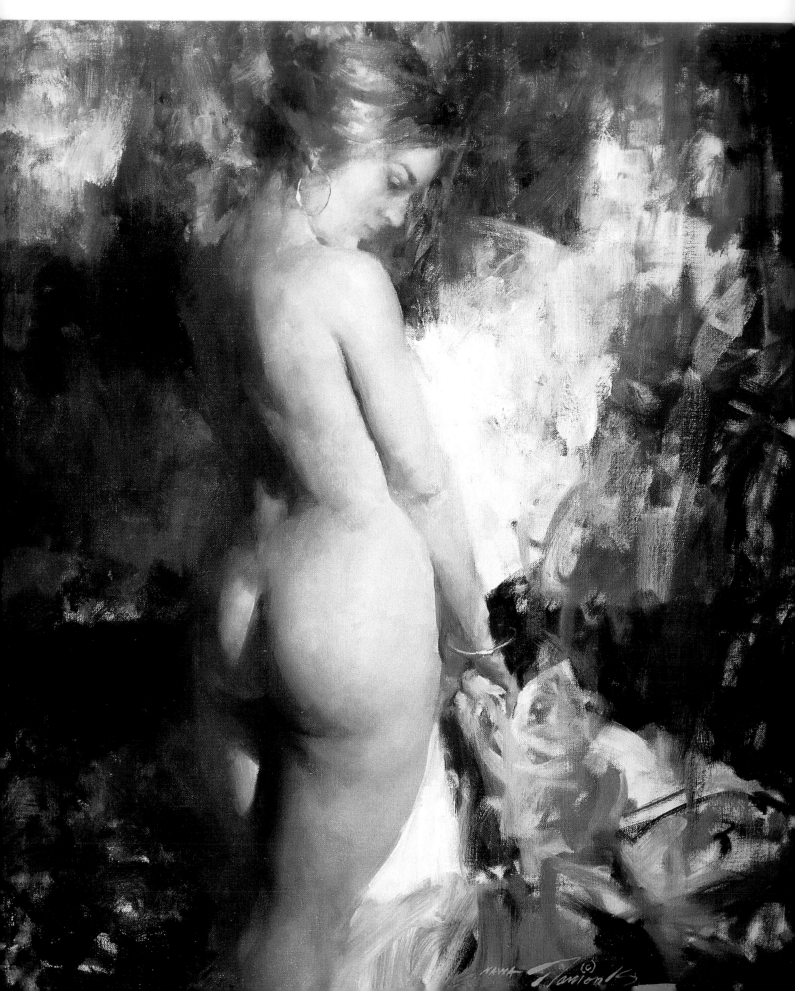

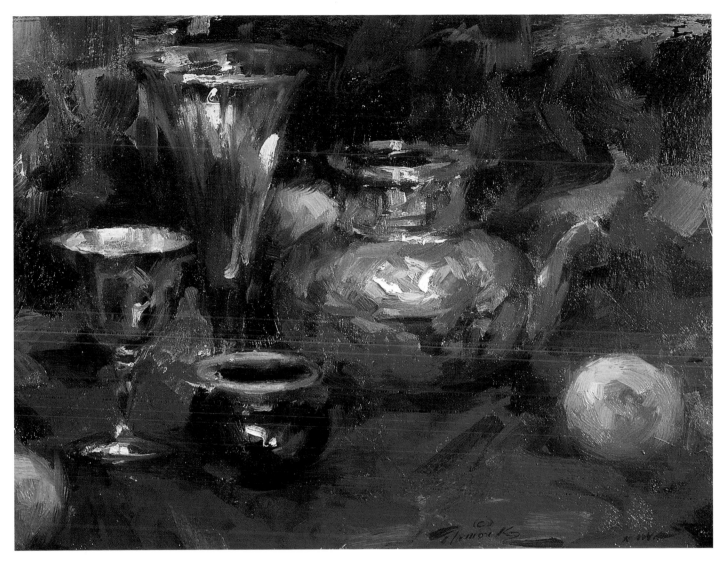

HOLDING COLOR IN CHECK

I was asked to be part of a show that paid homage to the Fauves, the early 20th century painters who used wild colors for their expressive qualities. I decided to see how wild and crazy I could get with color, and the result was "Oranges and Brass", oil, 12 x 16" (31 x 41cm). What fun! This painting is loaded with every rich, beautiful color on my palette, but I used a limited range of dark values to hold it together. Only the brass pot — the main actor in this show — and the strategically placed oranges were allowed to go lighter.

SCULPTING WITH VALUES

"The Spanish Earring", oil, 24 x 20" (61 x 51cm) contains very little pure or bright colors. Instead, it draws its dramatic strength from a full range of values — the chiaroscuro effect. It's as if the changing values are sculpting the body from the background, making the spatial depth and light source very clear.

ALLOWING FOR CORRECTIONS

In the early stages of a painting, I work all over the surface and loosely define the shapes with color and value. I would never want to work on one small area for two or three hours, and then discover that the overall composition is weak or that the placement of some elements are wrong. By that time, it would take too much effort to change the one thing that was right! But if I keep the painting loose in the beginning and develop all areas at the same pace, I can easily improve and correct the composition, structure and drawing accuracy as I go along.

And I find that I need to make changes almost every time. It's very rare for me to start and finish a painting without making corrections. I like to joke with my students that I start every painting by laying down my first mistake and spend the rest of my time correcting it! With this approach, I'm more likely to get it right eventually and be pleased with the end result.

FOCUSING ON VALUES

Learning to simplify shapes with value can be difficult, so I like to keep my skills up by doing 20- or 30-minute studies such as these small nude studies. The limited amount of time and the small size — no larger than 9 x 15" (23 x 38cm) — makes me focus on the values within the subject instead of the details.

DIRECTING WITH SHADOW SHAPES

The direct, overhead lighting in **"Taos Turban", pastel, 14 x 11"** **(36 x 28cm)** *was my key for tying this painting together. I linked the transparent cast shadows falling over this Taos Indian's face to subtly guide the eye around the portrait. This technique must have worked, since it won an award from the Pastel Society of America.*

INCORPORATING RANDOM VALUES

"Blue Beard", pastel over watercolor, 13 ½ x 13" (34 x 33cm) displays an exciting approach I sometimes take with my pastels. I begin with a 100% rag illustration board primed with pumice and gel medium, and then do a watercolor underpainting on it. I lay down random strokes of tonal color and then try to allow little glimpses of the underpainting to show through and contribute to the overall pattern of values in my subject. It's a fun and challenging exercise in working with value

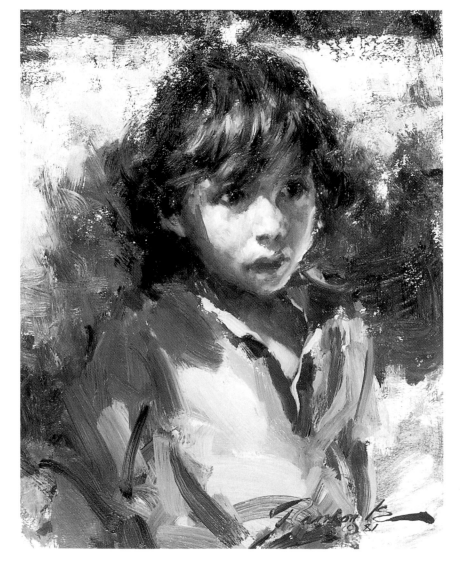

MAKING THE VALUES FLOW

"Thomas", oil, 12 x 9" (31 x 23cm) was painted on a very bright, sunny day in an outdoor setting. This meant the painting automatically became a high-key painting, but his black hair posed a problem. To keep it from looking like a dark orphaned shape, I reflected many lighter colors, such as light blue and browns, into his hair. I also added the dark shadow behind his neck to ease the transition of values.

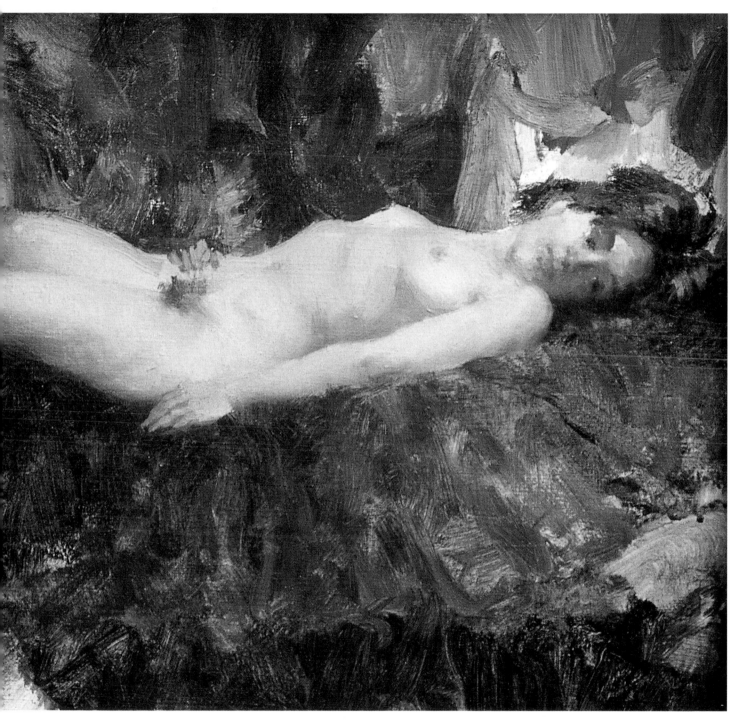

EMERGING FROM DARKNESS

"Quiet Thoughts", oil, 12 x 16"
(31 x 41cm) is a great example of the
dramatic effect of chiaroscuro — a
light object emerging out of a dark
background. At first, the model may
appear to be floating, but there are
enough cast shadows and directional
lines throughout the dark background
to give the setting dimension and
make it recede in space.

"Chiaroscuro is hard to do because I must
create gradual transitions from light to dark,
otherwise the values will have too much contrast,
which will shock the viewer."

ART IN THE MAKING — "OLD MAN WITH WALKING STICK"

As much as I may take artistic license with my subjects, I also let them dictate my approach to some extent. In this case, the model was wearing a black hat and coat. With all these neutral colors, I knew I had to build this painting on values. I decided to go for a chiaroscuro effect — a light image emerging out of the dark. But, because of the black hat providing a dark anchor above the head, I was able to break up the background into a more exciting combination of values.

I also put some "stuff", such as little accents of color and value variations, into the big shapes for greater interest.

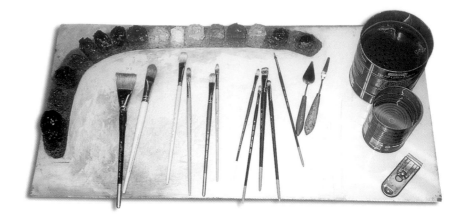

WHAT THE ARTIST USED

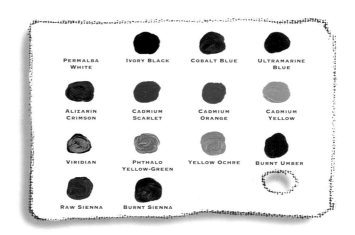

SURFACE
Oil-primed, heavy-textured linen

OIL PAINTS

Permalba White Cadmium Yellow
Ivory Black Viridian
Cobalt Blue Phthalo Yellow-Green
Ultramarine Blue Yellow Ochre
Alizarin Crimson Burnt Umber
Cadmium Scarlet Raw Sienna
Cadmium Orange Burnt Sienna

BRUSHES
Filbert and flats in several sizes (bristle brushes to start with and red sable or mongoose hairs in later stages)

PALETTE KNIFE

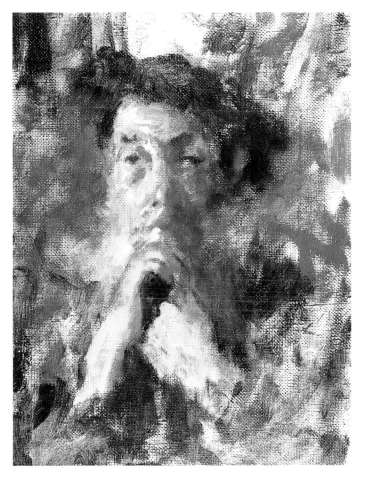

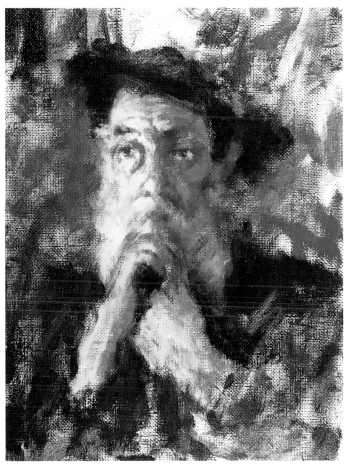

POSITIONING THE BIG SHAPES

I began by blocking in the medium value of each color within each big shape with big brushes. As always, I used my favorite combination of Cadmium Orange and Cadmium Red cooled off with Cobalt Blue and Yellow Ochre to keep the flesh tones from getting too hot. After placing the face and hands, I continued using big brushes to subtly position the hat, cane and jacket and to begin breaking up the background.

REFINING VALUES

With broad brush strokes, I continued loosely blocking in the hat and shirt, using black with touches of Cobalt Blue and Alizarin Crimson to make rich darks. I also decided to slightly lighten the values in the face and beard to define the three-dimensional forms there and to create better transitions from dark to light through this passage.

" . . . focus on mastering the two main uses of value
— creating depth and leading the eye."

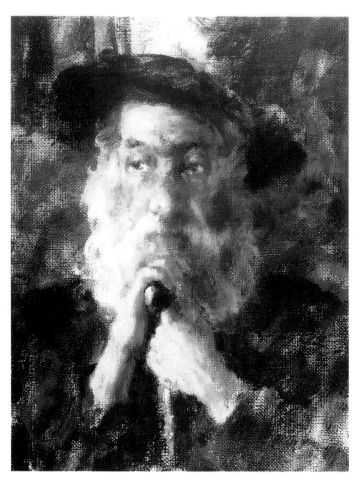

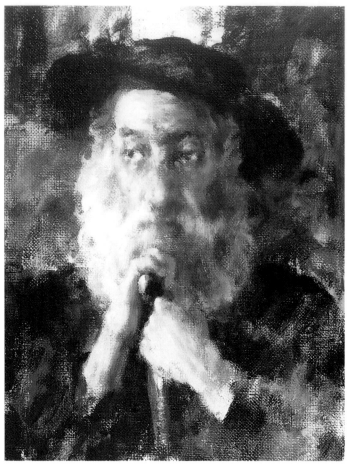

FLESHING OUT THE IMAGE

Once I was fairly comfortable with the positions and general values throughout the shapes, I began to refine the face and hands, making the drawing more accurate. I made his mouth wider and his beard fuller. I also darkened the shape on the upper right, and started tightening up the area around the hands with strokes of black. As an interesting invention, I added touches of red to the sleeves.

ADJUSTING THE TEMPERATURE

As important as light and dark values are to showing the direction of light in a painting, color temperatures play a part in this, too. So here I made the light side of the face cooler with accents of a mixture of Yellow Ochre, Cobalt Blue and White. Then I made the shadow side warmer — the shadow's temperature is always the opposite of the light's temperature — by adding accents of Cadmium Yellow mixed with Alizarin Crimson. Small, visible strokes of these colors were all that was needed to push the temperature in the right direction.

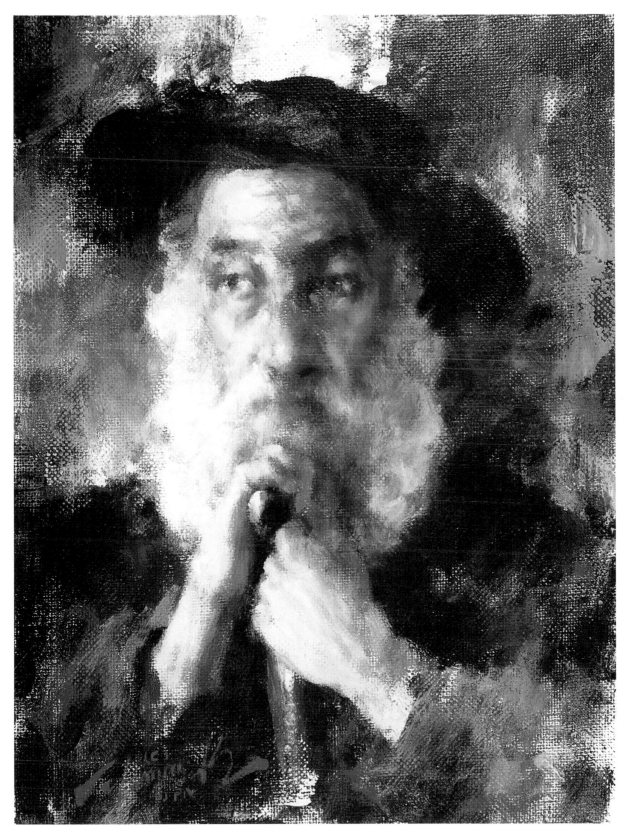

FINISHING WITH A TEXTURAL FLOURISH

A few more strokes helped to better define the features of his face and beard so that I felt quite happy with this painting at this point. The values were now correct, the drawing accurate and the overall color temperatures very good. I then used my palette knife for a greater variety of tones and textural effects in the jacket, middle left and right background. I thoroughly enjoyed painting **"Old Man with Walking Stick", oil, 18 x 14" (46 x 36cm)**.

The *4* *other* ESSENTIALS

Composition

When the sitter assumed this pose, he looked comfortable and natural, as if unaware he was posing. Besides adding character to a portrait, a gesture helps to create more interesting shapes. Without the hands, the body could have become part of a large, boring shape.

Color

A painting that's heavy on neutrals needs a splash of pure color for excitement. I chose accents of red because there was already a lot of red in the flesh tones. Repeating the same color helped to unify the image.

Texture

I picked a canvas with a heavy weave because it's compatible with the weather beaten texture of this old man's skin. I let it show through in some spots, but I covered it with a lot of paint in other areas for variety.

Focal point

A face is always a powerful focal point, but one small area must be more important than the rest of the face. In this case, I used the lit side and made it more prominent with harder edges. The slightly softer edges and middle values of the shadowed side of the face, as well as the hands, made them secondary areas of interest.

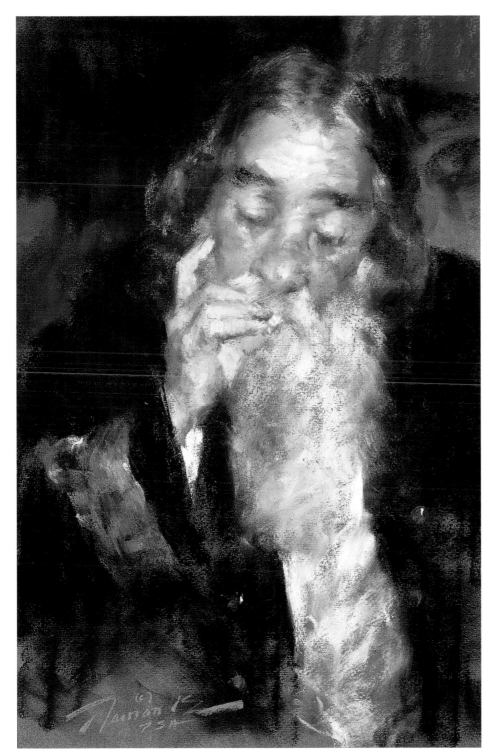

EMPHASIZING THE GESTURE

*When I paint a portrait, I prefer to catch my model in action, in some sort of gesture that reveals something about the person. In **"Smoking Man", pastel, 18 x 12" (46 x 31cm)**, I wanted to put the focus on what he was doing, and I used value to accomplish this goal. Notice how the hand is the lightest value, while the face, beard and shirt are lower down the value scale. I then surrounded this whole passage with contrasting darks to put the emphasis where I wanted it.*

THE ESSENCE OF VALUES

Used effectively, values can have two major purposes in a painting:
- Variations in value create the illusion of three dimensions because they suggest light falling over an object that has surfaces that change direction.
- Shapes with a similar value provide a structure for the painting. Within this structure, the shapes of values can be directed to guide the eye around a painting and lead back to the focal point.

POWERFUL PAINTING
with Color

Forget about all the complicated color theories you've heard! Instead, focus on the two forms of color contrast that will give your paintings presence.

As a young artist, I spent a lot of time studying the works of master artists of the past to see how they used color. But after about 10 years, I discovered that what worked for them didn't necessarily suit me. I spent another 10 years un-learning everything and finding my own approach!

Through experimenting with color, though, I found two concepts — two types of contrast — that allow me to be as mellow or as wild as I want to be without losing control and ending up with either a dull or gaudy painting. Of course, I start with the "local" colors, shadow colors and reflected colors in my subject, but then I modify them as needed to balance out my two types of contrast. I play neutral tones against pure, intense colors, as well as warms against cools, to bring out the excitement in my paintings.

Pitting neutrals against brights

I have to admit that when I dole out my tube colors on my palette, I am so tempted to start slinging those beautiful, vibrant, rich, intense colors around right away. Bright red, orange, green, yellow

— I feel like a kid in a candy store! It's easy to think that using all these beautiful colors in their purest forms will lead to a beautiful painting. But that's not how it works. Too much bright color looks garish and unnatural.

The secret to color that really rings true, yet still vibrates with excitement, is a foundation of grayed-down, muted colors balanced by a few notes of pure color. Minimizing the bright colors and using mostly contrasting neutrals creates a natural-looking color scheme and suggests that there's more color in the painting than there really is.

My favorite way to tone down a color is to mix it with another color, usually either Cobalt Blue (if I want to darken and neutralize a color) or Yellow Ochre (if I want to lighten and neutralize a color). Mixing with black or the color's complement are also good ways to gray down a color. I rarely use white to mute a color because I feel that combining two colors yields a more interesting neutral, whereas white strips out the color. I also avoid putting certain modern, synthetic colors, such as Phthalo Green, on my palette altogether. These bright, staining colors are so intense that it's almost

*For **"Innocence"**, oil, 11 x 14" (28 x 36cm), I posed this little model in an antique blue dress. I was concerned that the garment's blue color might dominate the rest of the painting, so I repeated hints of blue throughout the painting. They're so subtle that they almost disappear, but they really work to unify the image.*

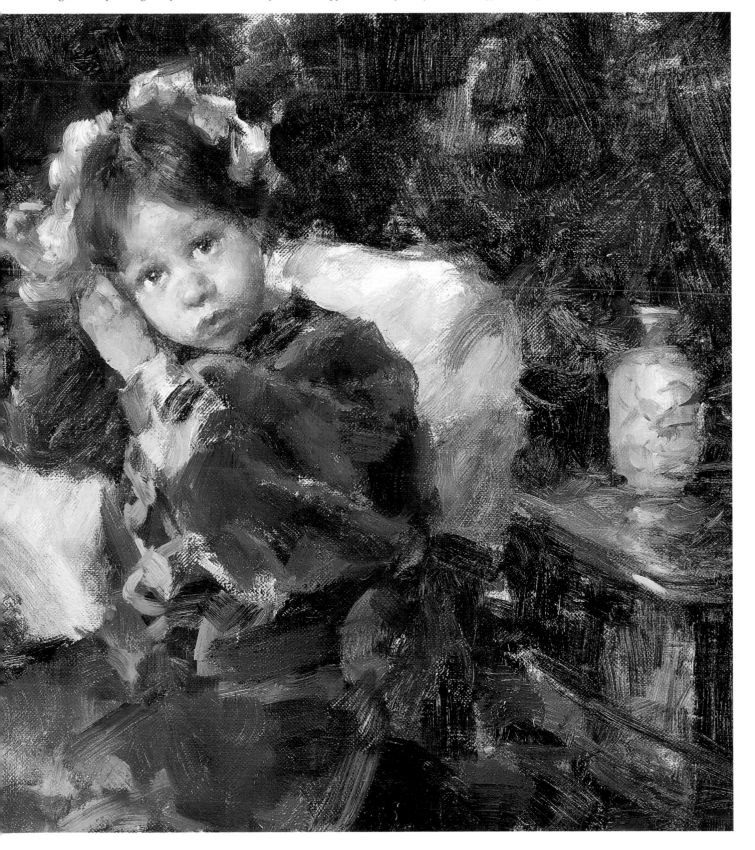

impossible to neutralize them. When I do use them, I apply them very sparingly, only where I want to go bright.

Balancing warms with cools

Just like my leaning toward bright colors, I also tend to consistently choose warm tones, which is common to most artists, I've found. But here again, the balance of contrasting cool colors is required to keep the painting looking authentic, yet interesting. This is only logical, because it's how the color of light works in nature. If the light source is cool (as natural, outdoor light usually is), the shadows are warm. If the light source is warm (as most man-made sources are), the shadows are cool. If nature balances warms and cools this way, I figure I should, too.

Given my penchant for warm colors, I have to fight for my cools. And once again, I usually add touches of one of my three favorite cool colors — Cobalt Blue, Yellow Ochre or Black — to balance my warms. In fact, I generally use the cool versions of my basic colors (Cobalt, Ochre, Alizarin Crimson, Viridian, Raw Umber) to modify and balance my warms (French Ultramarine, Cadmium Orange, Cadmium Yellow, Phthalo Yellow-Green, Burnt Sienna, Raw Sienna, Burnt Umber). When mixing colors, I'm less concerned with duplicating the color of my subject and more concerned with balancing the temperatures.

Repeating colors for balance

As you can tell, the key to my approach to color is balance — a balance of pure and neutral and a balance of warm and cool. I don't have any formula or ratio for achieving balance; I just make sure I repeat colors around the painting until it looks visually balanced. This allows a lot of latitude for exploring new combinations and different degrees of color intensities and temperatures. However, the result is always a mosaic of varied color that shimmers with excitement while still looking natural.

KNOW YOUR COLOR COMBOS

I think mixing colors is so much fun, not to mention a great learning aid. I highly recommend picking any two colors, mixing them up in equal portions and then adding white to create a value scale for that color combination. Keep doing this with different amounts of the same two colors, with other pairs of colors and even with three colors. This will teach you which colors to add to neutralize, modify the temperature of or change the value of any given color on your palette. Even after all these years, I still love to do this exercise because I'm always reminded of just how beautiful certain color combinations can be.

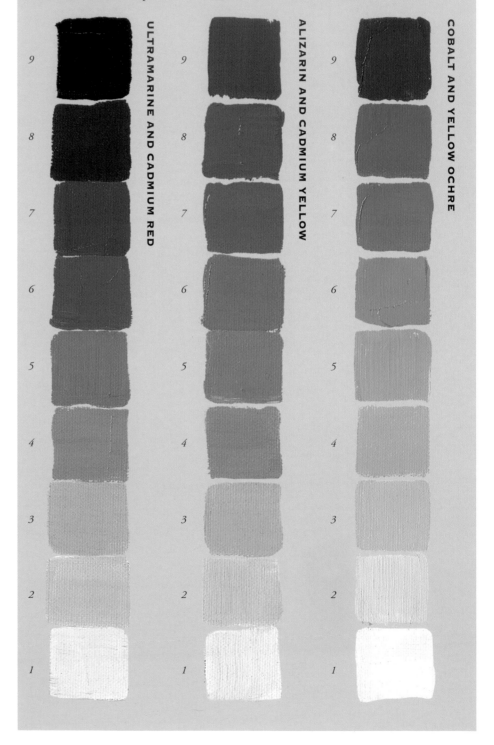

ULTRAMARINE AND CADMIUM RED

ALIZARIN AND CADMIUM YELLOW

COBALT AND YELLOW OCHRE

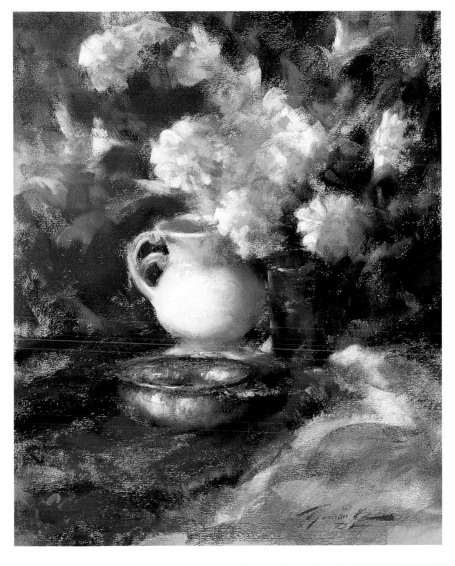

FOOLING THE EYE

At first glance, **"Still Life with Cobalt Blue and White Flowers", pastel, 18 x 14"** **(46 x 36cm)** *seems very bright and colorful. But look again. I actually used very little pure color, scaling back much of the magenta and blue. Even the white is softened with plenty of yellow. It's the contrast of the intensities that makes the painting seem so vivid.*

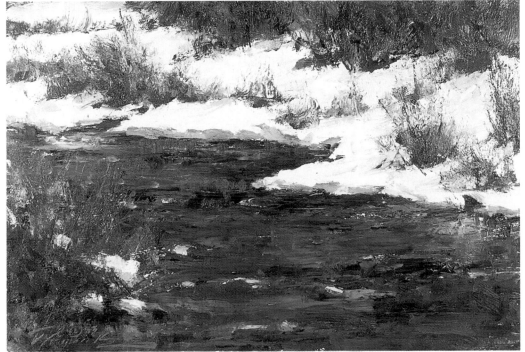

GOING NATURAL

*There are very few pure, bright colors in nature, so neutral gray tones are essential in painting realistic landscapes. In **"Roaring Fork", oil, 14 x 18" (36 x 46cm)**, in particular, I definitely wanted to capture the true feeling of the colors. As this was a very cold, snowy day, I used my coldest colors. The contrast of the few warm colors in the bushes make them even chillier.*

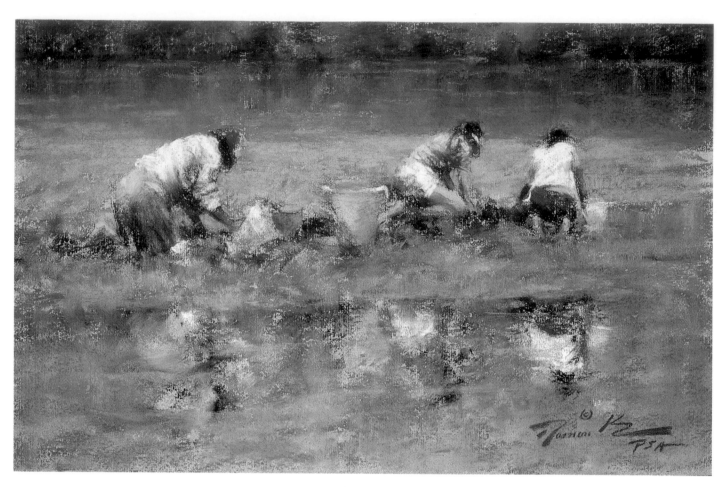

PLAYING WITH THE POSSIBILITIES

When I find a subject I'm particularly attracted to, I usually take a lot of notes, make sketches and sometimes even shoot photographs if it's a moving subject. With all of this reference material, I can then make several versions, as I did with these two paintings — one oil and one pastel — both called "Shell Diggers". Painting variations of the same subject, as Monet did, teaches me a lot about how colors work together and how colors vary from medium to medium.

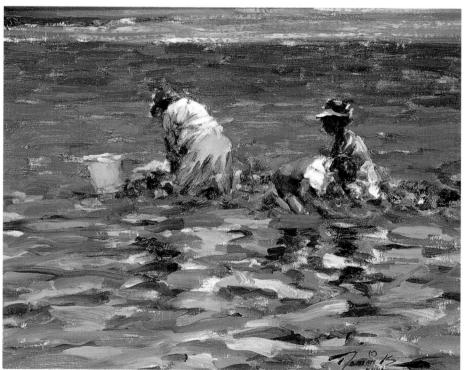

"The secret to color that really rings true, yet still vibrates with excitement, is a foundation of grayed-down, muted colors balanced by a few notes of pure color."

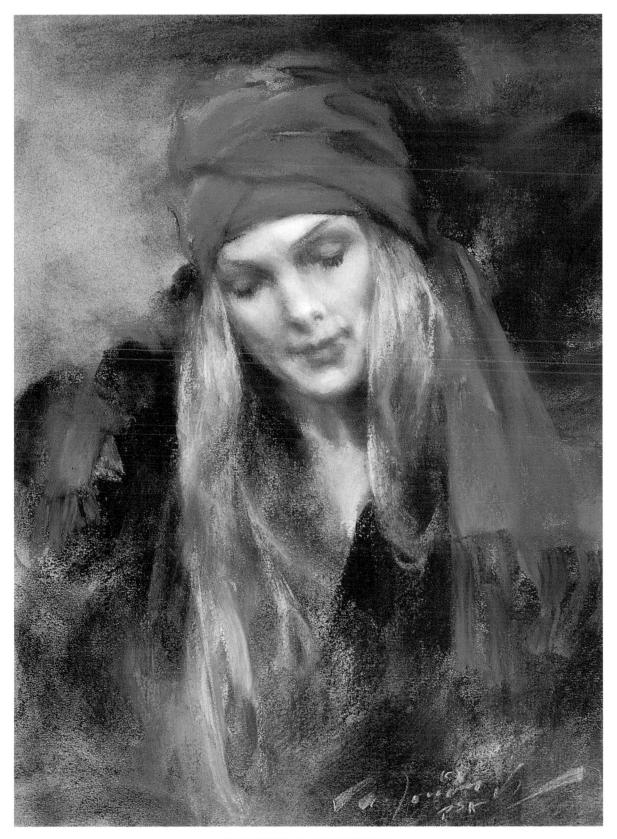

INJECTING A SHOT OF RED

*This model in **"The Red Scarf", pastel, 14 x 11" (36 x 28cm)** is a very pretty girl, but I wanted to do something other than a typical portrait and head study. My wife came up with a great idea of wrapping a red scarf around her head. Red is such an exciting color, guaranteed to add liveliness to any subject. Plus that great red shape makes a nice transition that pulls her light image out of the dark background.*

61

PICKING COLORFUL SUBJECTS

How much more color could you ask for? One of the reasons I'm so drawn to Central and South American subjects is that there is so much color to be found in these regions. The richness of the subjects automatically leads to bright, colorful paintings, such as **"Andean Colors", oil, 16 x 12" (41 x 31cm).**

GETTING THE MOST FROM THE MODEL

When I'm working with a live model, I'm always aware of the sitter's comfort. If the person poses too long and gets tired, he or she will lose the attitude of the pose. I don't want this to happen, so I try to work as quickly as possible and focus on making a broad statement about the face and figure. I can always clarify the features and put in the details of the clothing, props and background later, after the model is gone. An added benefit to painting quickly is that it forces me to work all over the canvas, which naturally gives a fresh, spontaneous look to the painting.

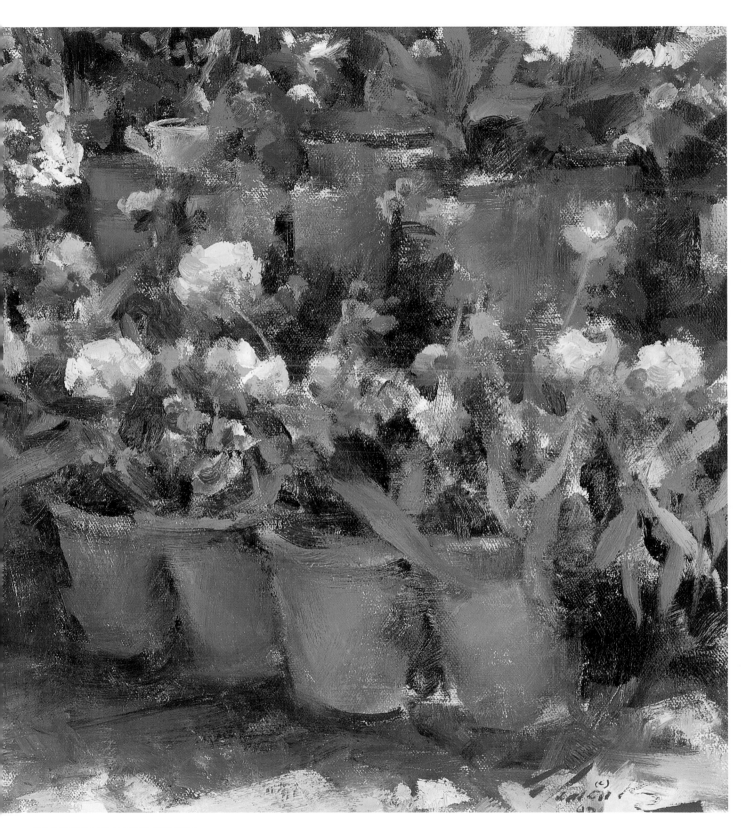

JAZZING UP YOUR GRAYS

*When I recommend using a lot of grays in a painting, I don't mean dull, lifeless grays. My favorite grays show visible signs of their original colors. Look at the flower pots and cast shadows in **"Flower Market", oil, 16 x 20" (41 x 51cm)**, for example. You can clearly see hints of blues, yellows and pinks throughout them — very exciting!*

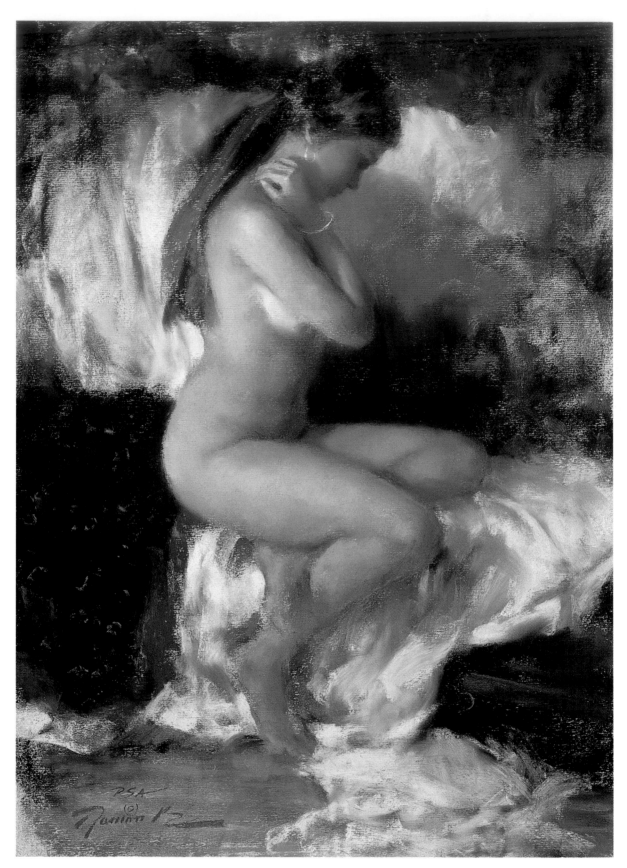

INTEGRATING TEMPERATURES

Even though I used a cool light source, the figure in "The Purple Scarf", pastel, 19 x 12½" **(49 x 31cm)** *was still quite warm and required some balance. I used the purple scarf and the dark blue and wine red shapes in the background for contrast. However, that cool light cast warm shadows in the background, so the mixture of warms and cools in the drapery helps to integrate the two. This won an award from the Pastel Society of America at the National Arts Club.*

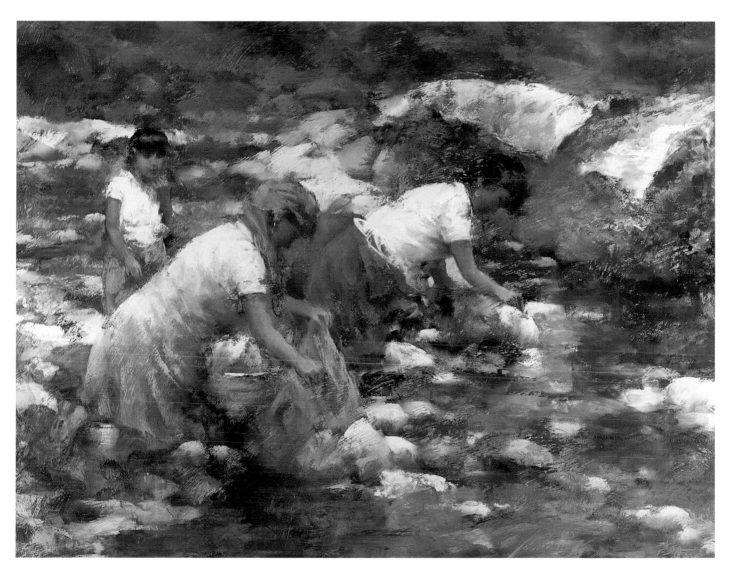

ORGANIZING WITH BRIGHTS

Winner of the PSA's Barbara and Vincent Giffuni Award, **"Washer Women of Oaxaca", pastel, 21 x 27"** **(54 x 69cm)** *is a rather daring composition. There is a lot of activity and many directional elements that could have made the design too busy. But I used color to keep it organized. Notice how your eye naturally follows a clear path of bright colors from yellow with red accents on the left to bright blue on the right. Surrounded by neutrals, these intense colors provide rest spots for your eyes.*

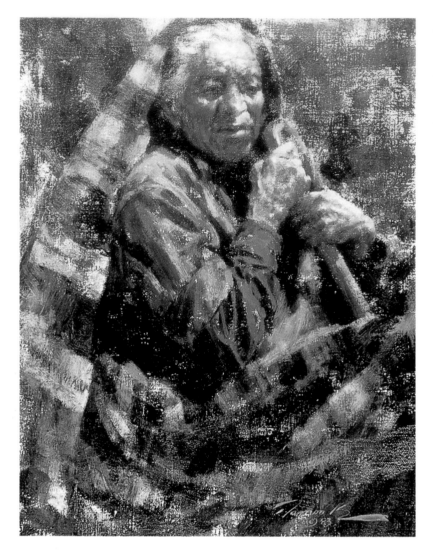

LIVENING THINGS UP

"Prairie Wolf", oil, 24 x 18" (61 x 46cm) is a look at a modern Native American wearing store-bought clothing and a blanket. Given the setting and subject, I thought it was appropriate to use mostly neutrals. However, a few notes of moderate color, such as the greens and reds in the blanket, as well as the brighter blue sleeve give this painting a spark of contrast.

INCORPORATING RANDOM HINTS OF COLOR

"Chili Peppers", oil on silk, 9 x 12" (23 x 31cm) was painted almost entirely with a palette knife. In addition to giving the painting great texture, this technique helped to integrate and repeat the colors as well. Each time I picked up a fresh color, I left some of the previous color on the knife, which then came off and intermingled with the new colors. These random bits of color fit well into a loose, spontaneous painting like this one.

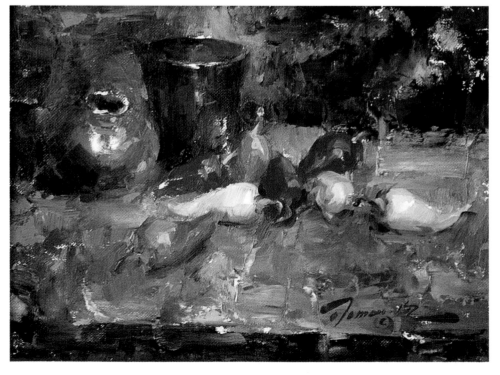

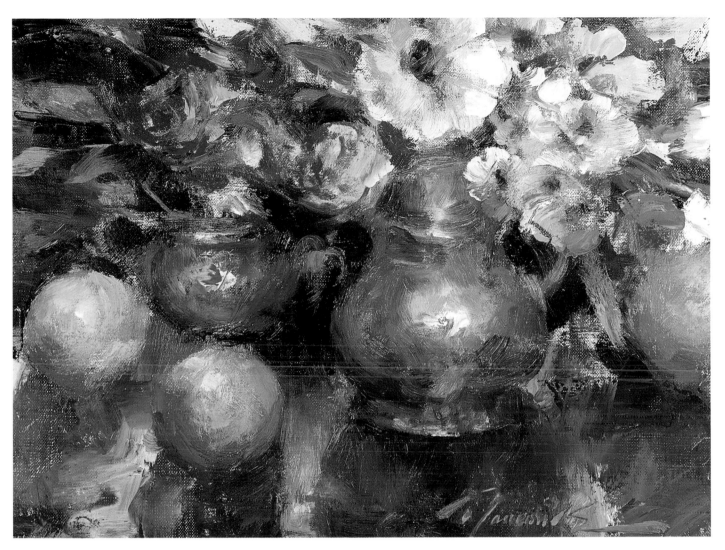

TURNING UP THE BRIGHTS

*The original set-up for **"Oranges and Brass Pot", oil, 12 x 16" (31 x 41cm)** had a lot of hot colors in it, which made it really fun to paint and very dramatic to view. I felt I could go pretty bright since the hot colors were placed consistently throughout the painting and not isolated in one spot. But as always, I brought in cooler neutrals in the shadows and table top for balance.*

WILL IT SELL?

When I'm choosing a new subject to paint, I never worry about whether it will sell. Experience has taught me to paint from the heart, doing what I want to do, so now I just paint with the intention of creating nice paintings. I figure that any painting that turns out well and has a good feeling to it will eventually find a home.

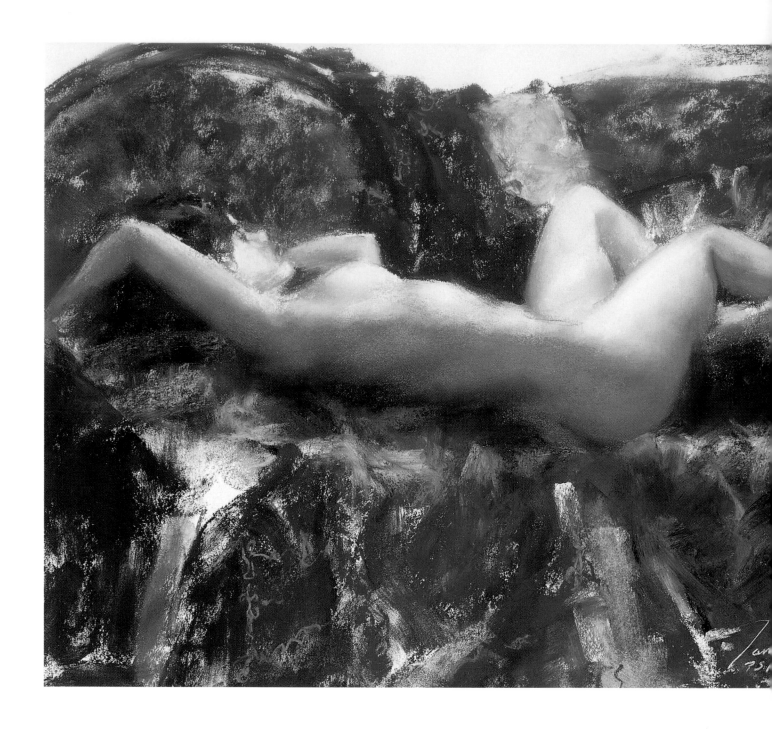

"I don't have any formula or ratio for achieving balance; I just make
sure I repeat colors around the painting until it looks visually balanced."

STAYING OUT OF THE MUD

"The Blue Vase", oil, 16 x 12" (41 x 31cm) is a gutsy painting, as I painted it almost entirely with a palette knife. With this technique, it's easy to make some serious mud, but I managed to keep many of my colors rich and explosive. How did I do it? A lot of practice has taught me how to mix lively neutrals and just where to put them to balance the brights.

CATCHING YOUR EYE

Viewers are almost universally attracted to the contrast of warms and cools, such as the cool pinks and blue surrounding the warm skin tones in "Lena", oil, 9 x 12" (23 x 31cm). People can't usually explain why they're drawn to it, but it's the subtle vibration given off by this type of contrast that pulls them in. It creates a little mystery and drama that catch their attention.

WALKING A FINE LINE

Wow! There's a lot of color in "Nude with Antique Drapery", pastel, 12 x 18" (31 x 46cm) . . . or is there? I admit that the warmth of the background is pretty powerful, but there are enough cools and muted tones to keep it from overwhelming the figure. Another important step I took was to integrate the cool blues into the figure so that she's not quite so isolated.

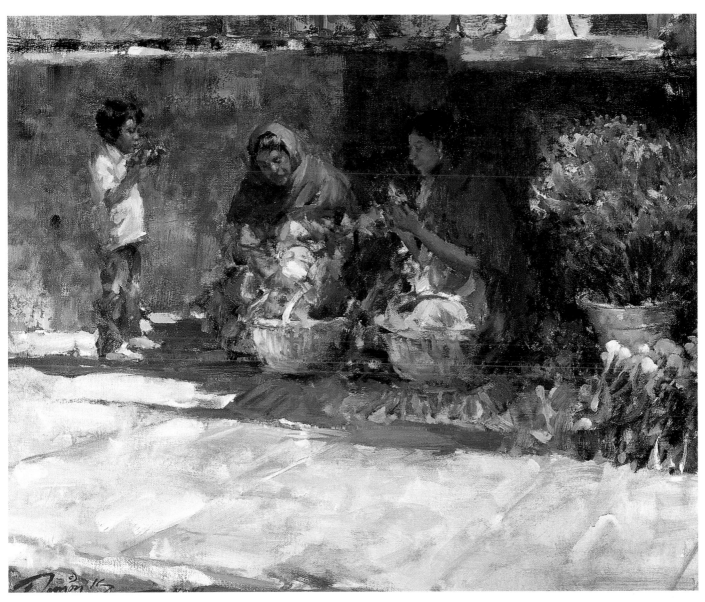

STRIKING A BALANCE

The activity and bright costumes of these street vendors in **"Se Vende", oil, 20 x 24" (51 x 61cm)** *made for an intriguing subject. But with so much happening, I definitely needed to use the two types of color contrast to maintain control. Notice how the cool brights are concentrated in the focal area, while plenty of warm neutrals balance them out.*

(LEFT) EXPANDING MY HORIZONS

"Little Girl in Blue", oil on linen, 20 x 16" (51 x 41cm) *proves that monochromatic needn't be monotonous. I used variations of the same color combinations of Burnt Umber, Yellow Ochre, Cadmium Red and Cadmium Orange for most of the painting, then painted the dress blue for a shot of purer, brighter color. This was also fun for me to paint. Because it was less colorful than usual, the different approach presented me with a break from my normal way of thinking.*

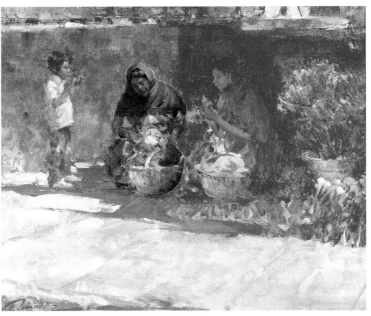

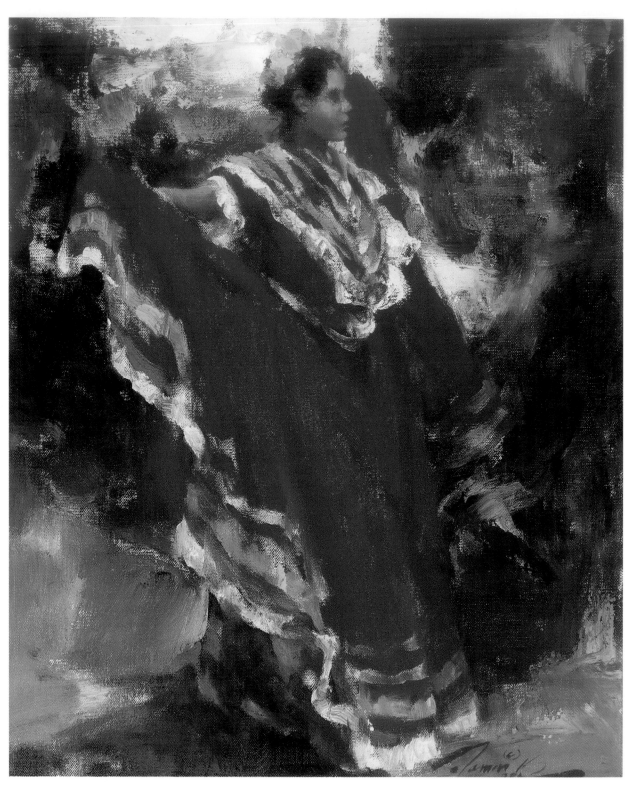

"When mixing colors, I'm less concerned with duplicating the color of my subject and more concerned with balancing the temperatures."

SUCCUMBING TO RED

*For me, red is perhaps the most exciting color in the spectrum. So the fabulous color and dramatic flair of the red dress in **"Folk Dancer in Red", oil, 16 x 12" (41 x 31cm)** made this an irresistible subject. I was delighted to paint this as a demo for my students. But the red, yellow and teal would have been too shocking if they'd been left alone. Notice how I included touches of these brights in my neutral background.*

ART IN THE MAKING — "THE DANCE"

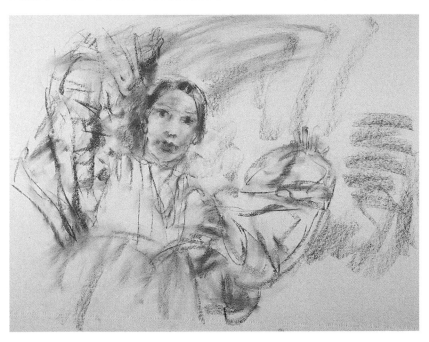

PLACING THE GESTURE

One of the advantages of pastel is that I can start by drawing lines, as opposed to blocking in large shapes, which allows me to be more specific and accurate in the drawing. That's what I did here, using a Raw Umber pastel stick that will accentuate the warm colors to come later. I tried to capture the gesture while paying attention to the placement of the shapes and the overall composition.

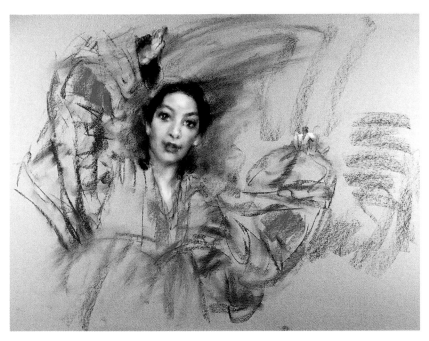

FOCUSING ON THE FACE

To create the tones of her face, I used medium-soft, light-valued sticks of cool Cobalt Blue, Yellow Ochre and Alizarin Crimson with warm touches of Cadmium Red. Although it was rather bold for me to develop the face this far this early, I wanted to establish the limits of my light and dark values so that I could choose the correct values for the rest of the painting. In these early stages, I gently blended the strokes to quickly cover a lot of ground and create a soft texture. I then placed a few touches of pink in her face and repeated this color in the dress.

The model for this painting happens to be my niece Lena, a beautiful young lady whom I've painted many times over the years. My goal here was not only to capture her likeness, her beauty, but also the beautiful rhythm of the pose. An unusual pose or gesture always makes a painting so much more interesting and attention-getting.

Of course, the bright colors of the dress posed an added challenge. I knew I had to choose more grayed-down pastel colors and use just a few sticks of pure color to make the painting look natural, balanced and believable. I also knew I'd be using a lot of warm tones in the flesh tones and dress, so I chose a cool paper to balance the temperatures. Together, these contrasts helped to capture the excitement of the subject.

WHAT THE ARTIST USED

SURFACE
Cool gray drawing paper

PASTELS
A variety of brands of medium and soft pastels for most of the painting, and some hard pastels for fine detail and crisp edges in the final stage

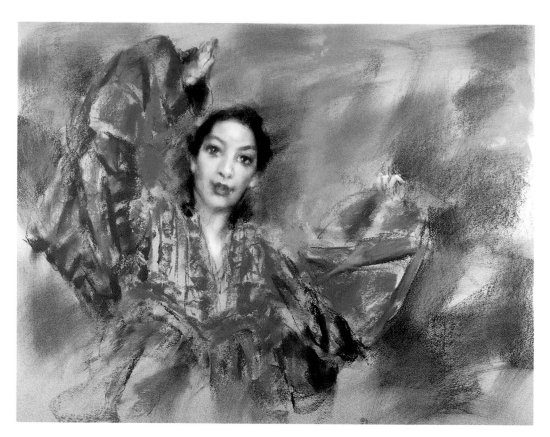

CHOOSING GRAYED COLORS

My next step was to get at least some color all over the entire surface before developing any one area. This would allow me to improve the design and flow of the painting while the shapes could still be easily changed. In the costume, which is a dress from Afghanistan, I saw very bright greens, pinks, violets, yellows, oranges and white in the fabric and beadwork on the front. But notice how I used muted versions of these colors to block in most of the dress, sometimes even incorporating other colors or the gray paper to tone down the colors. Only a few bright pinks and lavenders were applied toward the center of the painting.

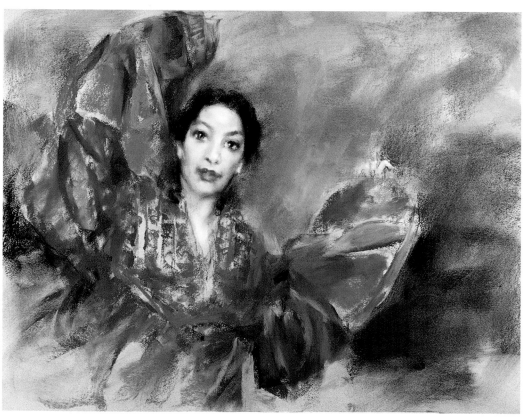

REFINING THE BIG SHAPES

I constantly re-evaluate my drawing as I paint, and here I decided to lengthen the arm on the left to improve the gesture and correct the drawing. Because the hand and sleeve were still loose and sketchy, it was easy to make this change even now. I then started to refine my big shapes by repeating more of the same colors in the background and placing strokes of color in the dress to accentuate the rhythm. I applied the strokes in much the same way I would have applied wet paint with a brush, which gives this the feeling of a true painting, rather than a drawing.

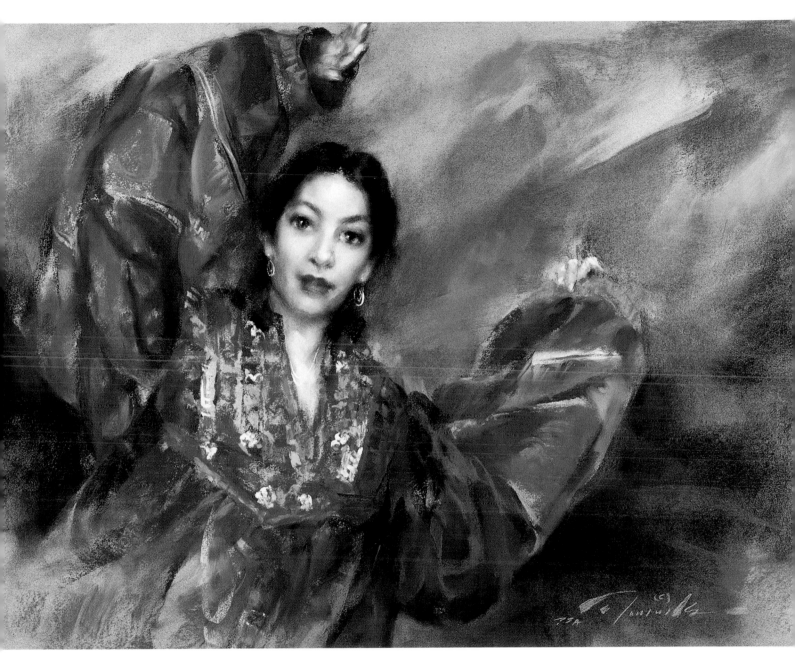

ENHANCING THE FOCAL POINT

*With a final check on my balance of temperatures and intensities, I enhanced the focal point with more definite strokes of color and harder edges all around the face. I then added a few details to the face and highlights in the hair, as well as the earrings and the beadwork. Finally, I used hard pastels to put in some hard edges between the fingers and along the lip line, nostril, eyelid and eyebrow in **"The Dance", pastel, 19 x 25" (49 x 64cm)**.*

The *4* other ESSENTIALS

Value

As I worked on developing this image, I decided to accentuate four different paths of light values that lead into the focal point. The repetition of these paths gives this painting rhythm.

Composition

The diagonal thrust of her body needed to be offset and balanced by other shapes, which is why I broke up the background with more subtle diagonals in other directions. I also positioned the body off-center, which adds drama.

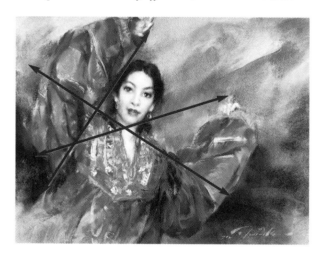

Focal point

Since the face is a rather small portion of this painting, I let the whole head function as the focal point. Many things make it stand out, especially the fact that it has both the lightest and darkest values. Contrast always attracts the eye.

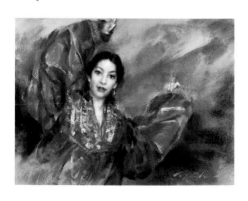

Texture

This paper has less texture than other pastel surfaces, so I had to suggest texture with the pastels themselves. I used very soft pastels for the big, bravura strokes on the sleeves, but somewhat harder pastels for the details in the beadwork.

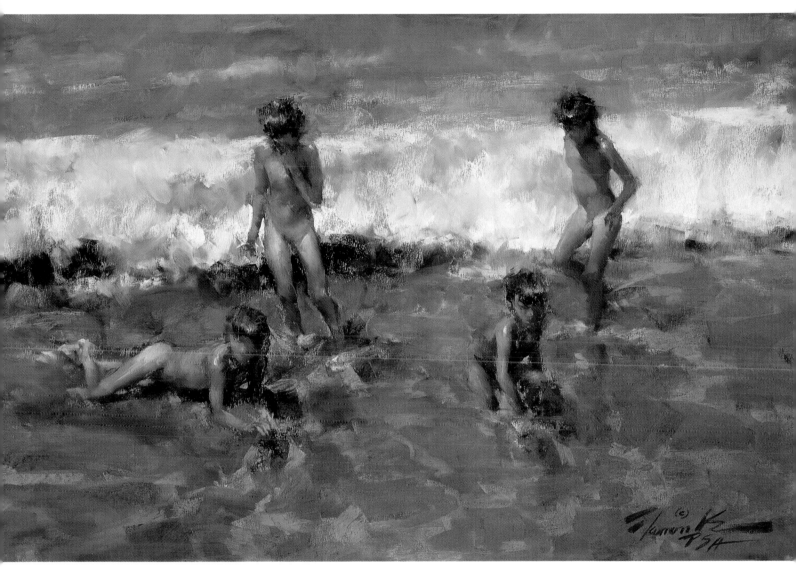

COOLING OFF HOT SKIN TONES

*One of the keys to painting believable figures is a knowledge of anatomy as it relates to color. All skin tones, no matter whether they're light or dark, are always warm, which is why I painted the four figures in **"Children on the Beach", pastel, 19 x 25" (49 x 64cm)** in such warm colors. Fortunately, the watery setting allowed me to balance those warms with plenty of cool blues and whites. However, notice that I repeated the warm oranges in the wet sand to tie the warms and cools together. This painting went on to win the Columbus Club Ladies Auxiliary Award for Excellence from the Pastel Society of America.*

THE ESSENCE OF COLOR

Keep your approach to color simple. Focus on balancing two important qualities of color in any painting:
- Neutral, grayed-down colors with touches of pure, intense color
- Warm colors with cooler temperatures

POWERFUL PAINTING
with Texture

Whether it's used for decorative effect or to provide a touch of realism to an object, texture adds excitement and vitality to every painting. Try my essential techniques for creating a full range of textures with oils and pastels.

I want my paintings to stand out as paintings — not just as pretty pictures, but as handmade works of art with tactile surfaces that viewers can "feel" with their eyes. For me, the best way to achieve this effect is through texture.

As much as I appreciate the power of texture, though, I recognize that it has to be controlled. Too much texture and the painting gets gimmicky, not to mention monotonous. Like so many other things in painting, the key to working with texture is variety and balance. I make sure that every painting has a range of different textures — some very active, some semi-rough and some smooth passages to give the viewer's eye a break. Although I use many different techniques to get the looks I want, they are all simple to master with a little practice and an understanding of the tools involved.

Incorporating the texture of the surface

In my paintings, texture often begins with the surface I'm painting on. If I'm doing an oil painting of a person, I usually choose a medium-textured linen. A heavier weave just doesn't seem appropriate for my style of portraits or figures. But if I'm painting a landscape or a still life that can accommodate a bit more texture, I might consider switching to a hardboard or wood panel that's been primed in a way that adds some roughness. For instance, I like to prime boards with rabbit skin glue covered by a coat of Flake White, which I then spread around in random strokes with a heavy bristle brush.

For my pastel work, I typically choose a French or German drawing paper that has a little tooth to hold the pastel pigment. Occasionally, though, I do work on other surfaces. It's fun to experiment with cold-press watercolor

COMBINING APPROACHES

*There are times when I want a texture to stand on its own and add decorative interest, and other times when I want the texture of the paint or pastel to suggest the texture of the object or thing I'm painting. In **"Launching the Flat", pastel, 19 x 24 ¾" (49 x 64cm)**, I have a little of both. I used individual textural strokes to make the group of figures — my focal point — simplified, yet interesting. But in the middle ground, I left the strokes rough so they would look like tumbling waves. Then I smoothed and blended the strokes in the foreground to look like wet, watery, reflective sand.*

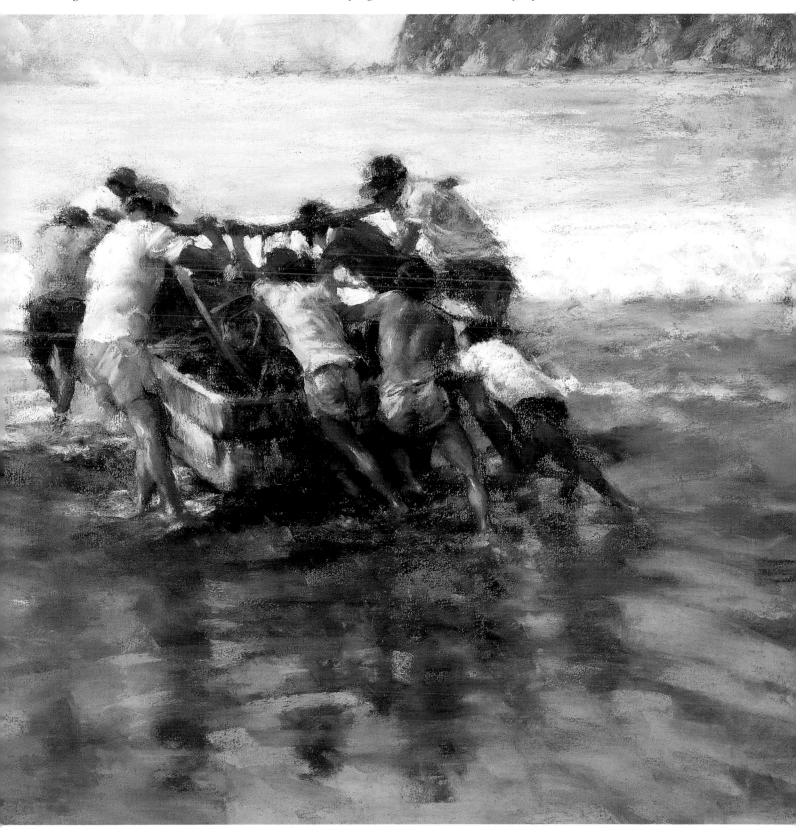

paper or with a 100% rag paper that I've sanded with a light-grade sandpaper and then sprayed with a workable fixative to create tooth on the surface. And once in a while, I like to cover some smooth surface with pumice or marble dust mixed with acrylic gel medium.

Creating texture with the medium
Although I like to have the option of incorporating the surface's texture into my paintings — and in fact, need it for my pastel paintings — I much prefer to create textures with the medium I'm using. The process for creating variations in the paint is apparent in every step, every stage, every stroke I make. Texture can't be added in the final development of a painting; it must be built in from the beginning.

In general, my textures come from laying down visible strokes in different directions. I never put down more than five strokes all going in the same direction. That's boring! Random, intersecting strokes covering an area look far more interesting. Placing the strokes at differing distances apart adds to the effect, as does using various stroke lengths. My favorite is a short "chunk" of color! And another thing that makes for attention-getting texture is changing the pressure I apply when making the strokes. All of these techniques lead to variety and contrast, which is always the best way to go.

When I'm working with oils, I could put in even more variety by adjusting the density of my paint with turpentine or some other medium, but I don't like to do that too much. I like to work alla

PLAYING SECOND FIDDLE

"Little Chris", oil, 12 x 11¹/₂" (31 x 29cm) was about chiaroscuro, light values coming out of dark. Given the small format of the portrait and my intended focus on values, I had to be careful with the textures to prevent them from detracting from my main objectives. The only place I really allowed a lot of texture to come through was in the face. These minimal textures kept the painting simple and let the values stand out.

APPLYING OILS

If you're painting in oils, try experimenting with the amount of pressure you use on the brush. Changing the amount of pressure changes the width of the stroke as well as the amount of medium laid down in the stroke, allowing you to put a lot more variety in your textures, as I've done here. It also allows the surface to show through where you want it to, leading to transparent passages among the opaque areas.

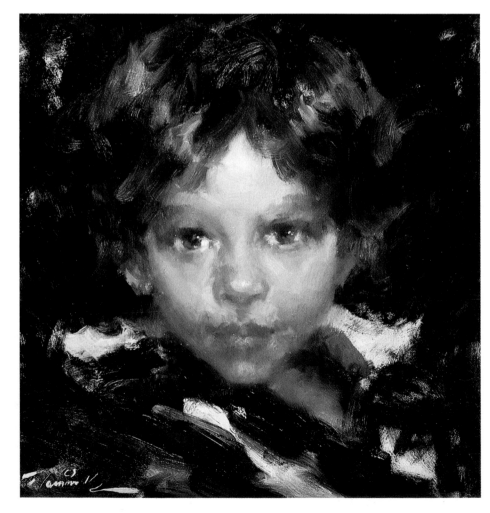

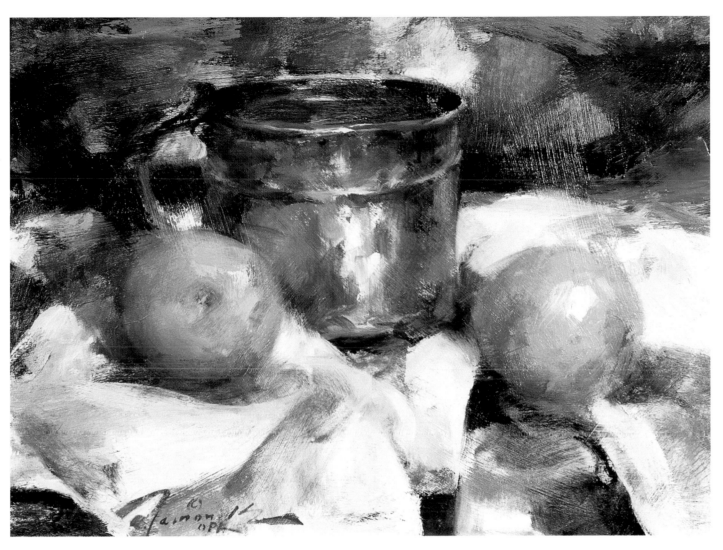

USING THE PALETTE KNIFE

This technique is something I recommend only to more advanced artists who've mastered the brush. It requires a lot of precision and control, otherwise you'll need to blend away your mistakes which usually ends up looking muddy. When you do use it, hold the palette knife lightly and practice often so you can get the feel of it.

ENHANCING BEAUTY

Texture can transform the most ordinary, humble objects into a beautiful painting. Look at "Brass Pot and Oranges", oil, 8½ x 11½" (21 x 29cm), for instance. On a board primed with visible brush strokes, I put down background chunks of color, then scraped them off to leave nice color tones. I also used palette knife work and brush work to create the textures of the pot and drapery. The simplified oranges then provide resting spots for your eye. This combination of smooth, lean areas with fat, juicy passages makes the painting exciting.

prima, all in one session, with heavy paint pretty much straight from the tube. This way, I don't have to wait for any slow-drying additives to set up before I continue. Heavier paint also allows me to employ many of my favorite application techniques, such as dragging through wet paint with a clean brush, drybrushing with a barely loaded brush or scumbling one color over another.

The tools I use to apply the oil paints also have a big effect on the textures. I use mostly bristle brushes, either flats or filberts, because their coarse bristles leave nice, visible lines within each stroke. I reserve softer filbert and round red sables or mongoose hair brushes for the final stages when I want to soften some textures with a little blending. Another tool I favor is the palette knife, which forces me to apply the paint in flat, thin strokes, creating a different look in the finished result.

With either brushes or knives, though, I make sure I hold the tool lightly, like an orchestra conductor's baton, so that I have a full range of motion in my fingers, wrist, elbow and shoulder. Variety in the strokes comes from the unrestricted movement of the tools.

I apply my pastels in much the same way I apply oils — in deliberate strokes made with the sides of the sticks, rather than in hatched or cross-hatched lines made with the ends of the pastels. And just as I do with a brush, I vary the pressure, sometimes hitting just the peaks of the paper like drybrushing and other times pushing the pigment deep into the nap of the surface. I've found the only other tool I need for varying the texture of pastels is my finger, which I use to move the pigment around and feather the strokes.

Knowing where and when to use texture

To varying degrees, I use texture in every one of my paintings, always with a particular effect in mind. Because I've learned exactly what to expect from my different texture-making tools and techniques, I know how to create a specific texture that replicates — or even just suggests — the look and the feel of the object I'm painting. The skin of a young woman is very different from the skin and of an old man, and that should be obvious from the way I've painted them! By the same token, I know how to create more random textures that add interest to some portion of a painting without overpowering the focal area. Either way, however, I apply my paints or pastels with variety right from the initial block-in so that my textures appear fresh and lively in the finished painting.

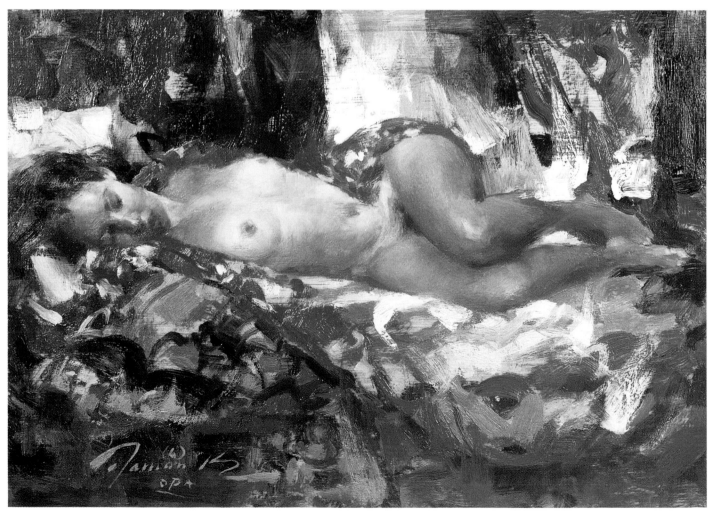

PAINTING WITH PASTELS

Pastels are quite versatile. Their points can be used to draw lines, or their sides can be used to lay down strokes of color — just like a brush — which is the approach I prefer. When making strokes of pastel, vary the pressure, sometimes hitting just the peaks of the paper to create a drybrushed effect and sometimes pushing the pigment deep into the nap of the surface.

And if you really want to blend a stroke of pastel, use your finger. All other tools, including brushes, rags, chamois cloths and paper towels, all lift the pigment from the surface. Your finger is the only thing that will leave the pigment on the paper as you move it around to alter the texture.

GETTING TEXTURE IN A SINGLE SHOT

When I get in front of the easel and tell myself I can do something — and really believe it — I can do it. With **"Ashley in Colorful Kimono"***, oil, 10 x 8" (26 x 20cm), I decided I was going to put on more paint than usual and give the finished piece a tremendously powerful presence through textures. For example, in the right background, I laid down big strokes and left them. On the right, I used a palette knife over a darker underpainting for variety. And for the robe, I used longer brush strokes in a mosaic of colors and values. With this approach, I needed very little overpainting, keeping everything fresh and direct. What impact!*

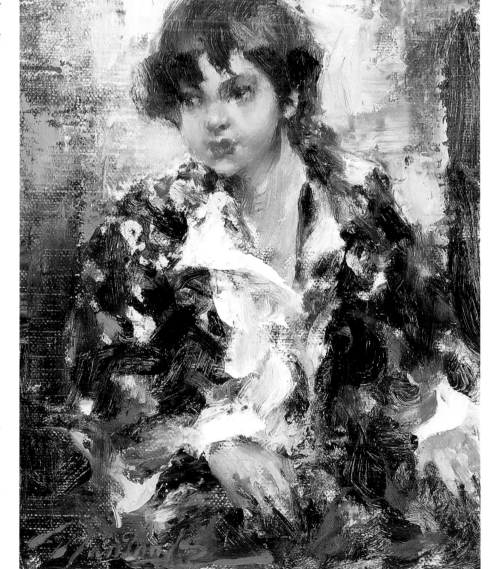

(LEFT) TRYING SOMETHING NEW

Nineteenth century Italian and Spanish painters worked on little boards called "tabletas". Intrigued by this idea, I decided to paint **"Cigar Box Nude"***, oil, 7½ x 10½" (19 x 26cm) on the cover of a cigar box. I primed the surface first so that the paint wouldn't be absorbed into it. This created a slick surface, which allowed me to push the paint around a little more than usual. I let myself go and had fun with it, and I like the resulting shapes and chunks of paint, where the strokes themselves became shapes. I enjoy experimenting with fun projects like this one.*

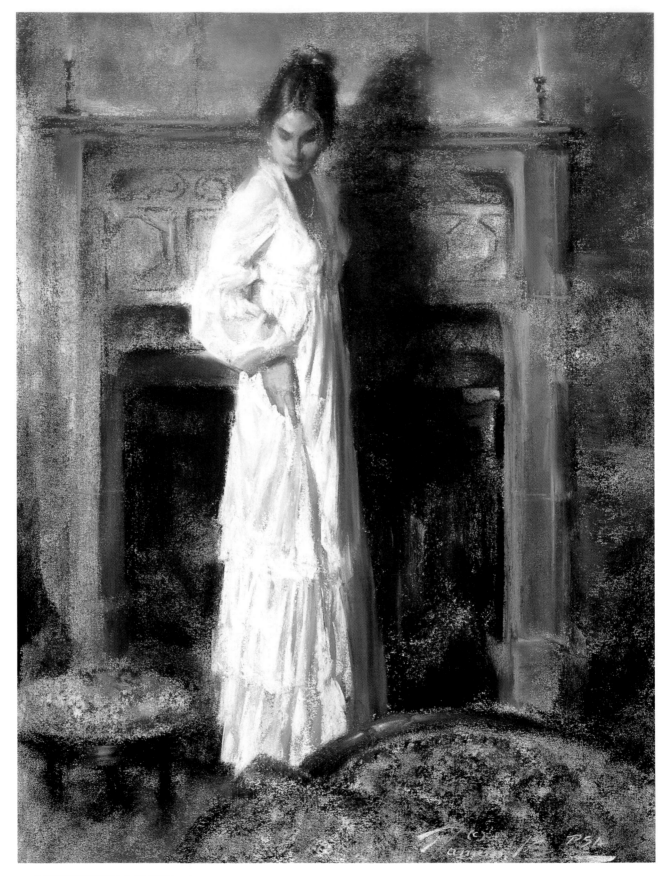

SUPPORTING A MOOD

I wanted "Antique White", pastel, 18 x 14" (46 x 36cm) to have a romantic, nostalgic mood, as well as a sense of mystery that would invite the viewer to participate in the painting. In keeping with this, I chose a nearly monochromatic color scheme. But then the textures and the directions of the strokes became very important in keeping the painting from becoming boring and monotonous. Notice how I varied the length of the strokes and the amount of pressure I applied.

"Koi", oil on panel, 16 x 20" (41 x 51cm) presented a unique challenge for me. I usually work alla prima, completing paintings in a single session, so I tend to lay down my paint in fairly heavy strokes and passages. But that wouldn't work for the flowing, delicate fins of the koi. To give these areas greater fluidity, I thinned my paint with a little turpentine, allowing the paint to flow more easily off my brush. Not only did this approach provide the right look for the fins, it added variety against the shimmering chunks in the scales.

DETAIL

"The process for creating variations in the paint is apparent in every step, every stage, every stroke I make. Texture can't be added in the final development of a painting; it must be built up from the beginning."

CREATING AN ORIGINAL

I try to be original in presenting my subjects so that they express who I am. For **"Little Jim"**, **pastel, 12 x 9" (31 x 23cm)**, I took a very unusual approach to painting. On paper primed with pumice and gel, I laid down texture here and there. Then I toned the paper with random strokes of watercolor. Next, I went in with pastel, but did not put down a lot of pigment in many areas so that the watercolor came through. In the final pass, I defined just a few areas, such as his hands and the left side of the robe. Here, drama comes from a simplified presentation, where the image is more suggested than heavily detailed.

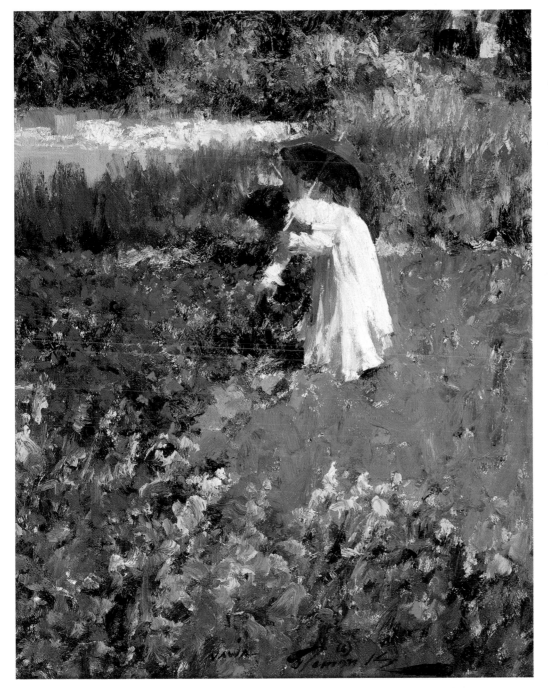

DIRECTING WITH TEXTURE

*Used creatively, texture can guide a viewer's eye around a painting just as much as shape, value or color. In **"Mona in the Garden", oil, 14 x 11" (36 x 28cm)**, I used the textured strokes of the foreground flowers to point you toward the figure. Then I used softer, feathery strokes of grayed purples in a pattern across the left background to hold your attention there.*

DETAIL

(LEFT) SCUMBLING IN PASTEL

*One of my favorite texture-making techniques in pastel is scumbling, dragging one color over another. You can see it in the middle left and along the bottom of **"Silver Bowl with Fruit", pastel, 10 x 16" (26 x 41cm)**. This is a beautiful way to lightly blend color while retaining some subtle textural strokes.*

PAINTING WITH THE KNIFE

I think *"Lilacs and Oranges", oil, 20 x 16"*
(51 x 41cm) is one of my most exciting pieces
to date. Almost everything was laid down with
the palette knife — first the big shapes to place
the elements and get the values down, then
dark and light accent colors to integrate shapes
and build texture. Finally, I added the
highlights with a soft brush. This technique is
hard to do with any kind of accuracy, but the
results are beautiful and interesting.

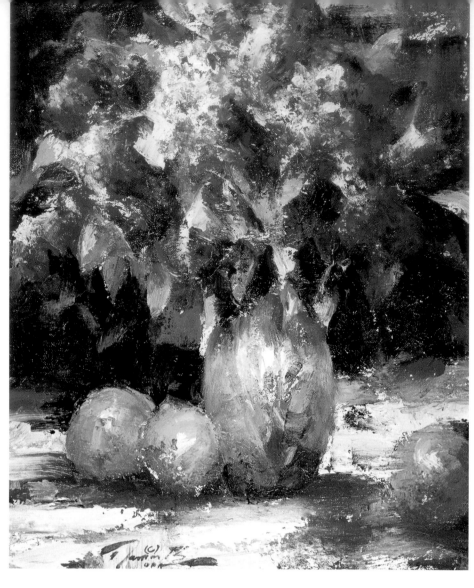

DETAIL

STANDING OUT IN
A CROWD

One of the hallmarks of
my style is how I combine
abstracted backgrounds with
realistic subjects, as I did in
"Little Luisa", oil, 9 x 12"
(23 x 31cm). Here, I painted
the face almost entirely with
the brush, while everything in
the background was created
with a palette knife. It's a bold
approach that makes my work
distinctive.

HINTING AT SURFACES

Sometimes I want to suggest the materials that objects are made from without actually describing them in great detail. For example, in **"Mountain Man", pastel, 16 x 12" (41 x 31cm)**, *I wanted to show that his coat was a heavy, rough fabric, his hat was fur and his pocket watch was gold. To do this, I used simple, textural strokes to represent the surfaces of these revealing, yet secondary, objects. Merely suggesting the objects' surfaces kept them from becoming too obvious and pulling attention away from his face and expression.*

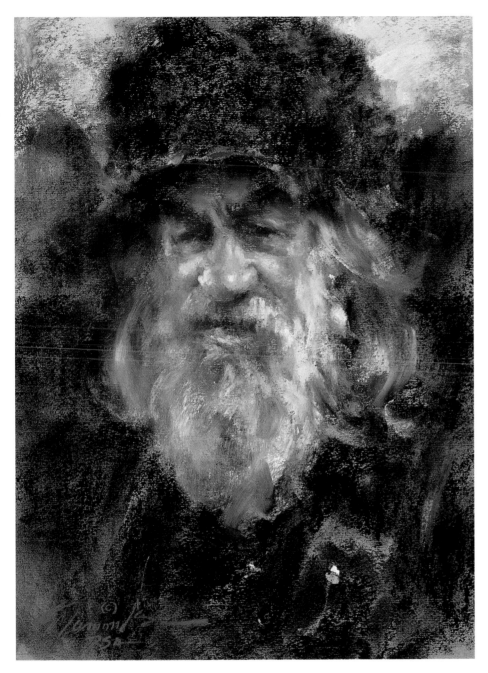

DETAIL

" . . . the key to working with texture is variety and balance."

FIND YOUR FAVORITE SURFACES

The surfaces shown in these paintings are just my preferences. All artists need to experiment with a wide range of surfaces to discover what feels right to them personally. When you find those materials and techniques that feel comfortable to you, it's a sure sign that you're expressing what's inside of you. So try different options, keeping these guidelines in mind:

- Know your limitations. A highly textured surface is difficult to work on and requires advanced drawing and painting skills.

- Understand that more surface texture doesn't necessarily mean the painting will look better. You'll be amazed at how little texture you need to catch the paint.

- Keep it "legal", meaning archival. Research which materials are compatible — oil primers under oil paints, acrylics with aqueous media — to prevent your paintings from cracking, flaking or warping later on.

- Choose something that will let you get to work right away or else plan in advance.

Experimentation is a must. You're only as good as the medium and surface you're working with, and the only way to learn is to keep trying over time.

DETAIL

DETAIL

TAKING SIDES

Most pastel papers have two different textures, a rougher weave on one side and a smoother texture on the other. I don't like the rough side because the weave shows up as a repetitive, grid-like texture. So I usually choose to work on the smoother side, especially when I'm painting a subject with a smooth, soft texture like this nude, "Lady with White", pastel, 18 x 14" (46 x 36cm). In general, I'd rather create texture with my medium than try to work with a mechanical, all-over texture in my surface.

DETAIL

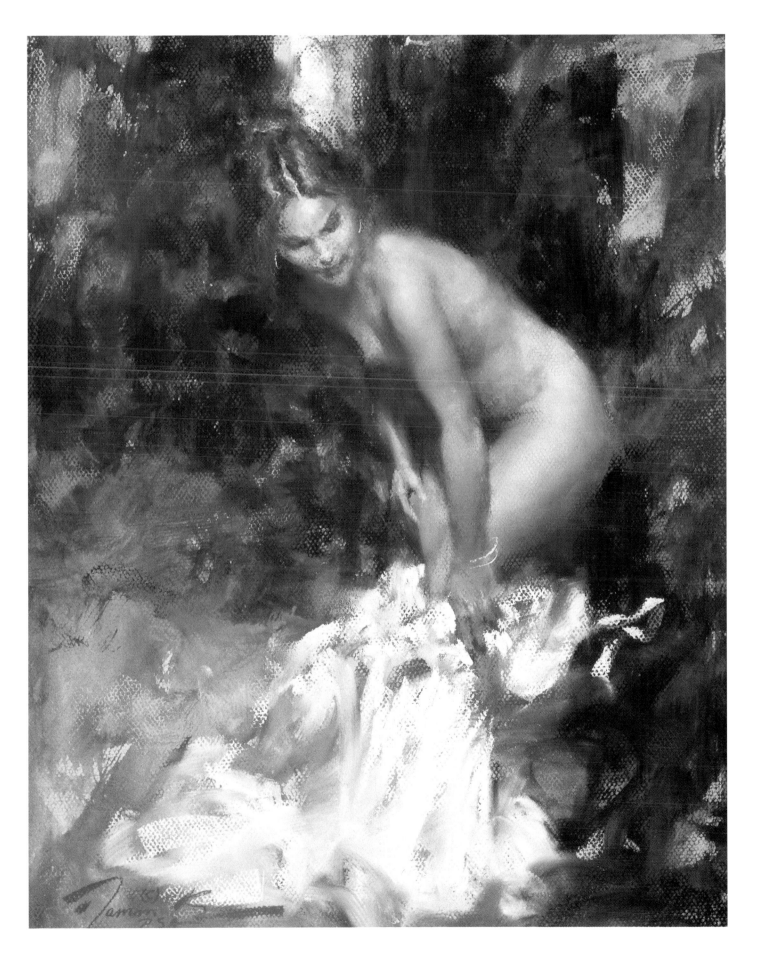

*Sometimes my compositions contain a very large shape that needs to maintain a fairly even value, such as the clothing and robe in **"Ashley's Robe", oil, 16 x 12" (41 x 31cm)**. Without something to break it up, a big shape can become repetitive. This is where texture becomes very useful in adding interest while maintaining the structure of a painting.*

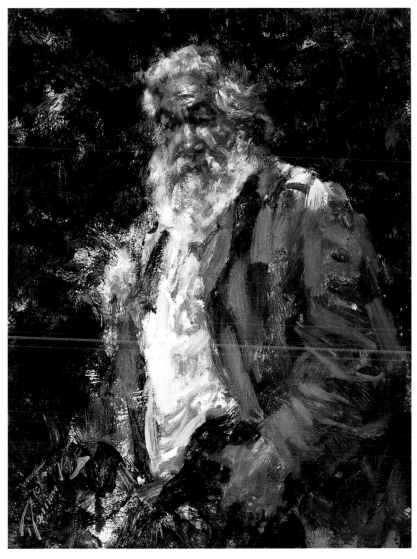

VARYING MY STROKES

Everything in "An Old Character", oil, 16 x 12" (41 x 31cm) is constructed out of strokes of color. I used short chunks of color to sculpt the face, longer strokes to suggest the draping fabric in the clothing and varied, random strokes to fill the abstracted background. Not only is this approach fun to do, it makes the painting far more interesting for the viewer.

MAKING SOMETHING HAPPEN

In terms of design, "The Meeting Place", oil, 18 x 24" (46 x 61cm) needed a vast foreground to balance the busy architectural details of the building and gated fence. To make that large shape more interesting, I filled it with texture and cast shadows suggested with broad, loose strokes of heavier, more opaque paint in cooler temperatures. Notice, however, that the strokes lead to the focal point.

ACHIEVING SPECIFIC EFFECTS

*Early on, I didn't understand how to make specific textures — I thought I just needed wet paint. But with experience, I learned that I could achieve certain looks by using different brushes and changing the thickness of the paint. I discovered that a rough old wall, such as the one in **"A Resting Place", oil, 16 x 20" (41 x 51cm)**, requires a dry brush effect. To do this, I lightly load the brush with paint, wipe it first across my palette, then gently drag the brush over the linen surface.*

ADDING A TOUCH OF MYSTERY

*I chose a heavier Russian linen for **"Little Girl in Spanish Dress", oil, 20 x 16" (51 x 41cm)** because I wanted more texture, in keeping with the flair and movement of the dress. I allowed a lot of the surface texture to show through, and added even more with palette knife work and unblended brushstrokes. Because everything isn't clearly rendered, the painting has a little mystery to it, which encourages viewers to participate in my work.*

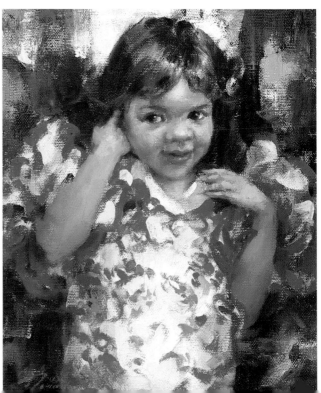

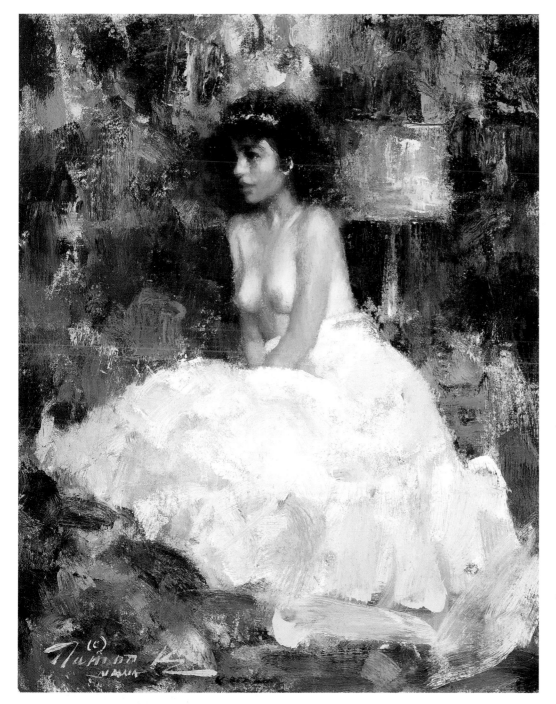

ACHIEVING A BALANCE

The old saying "less is more" is very true of texture. A lot of exciting texture all over a painting would be both too busy and too monotonous. There must be variety and contrast. Even in **"French Model", oil, 12 x 9"** **(31 x 23cm)** *where I pushed the activity in the surface pretty far, I used many different approaches. I used a palette knife in the background and a bristle brush in the skirt. Then I used softer brushes to smooth out the flesh to provide the viewer's eye with a much-needed rest area.*

DETAIL

Art in the making — "Portrait of Luke"

In this demo, you'll see how I build texture into every step. For me, trying to put it in at the end doesn't work — it doesn't generate the spontaneous, painterly effect I like to see in my paintings. Handled with care, these textures will add drama, vitality and energy to the finished painting without detracting from the main focus of the portrait.

My surface is an oil-primed Belgian linen in a medium weave. I don't like to have too much texture in the surface itself when I'm doing a portrait. Instead, I prefer to create textures by using heavy paint and applying it in a variety of different ways with both brushes and a palette knife.

What the artist used

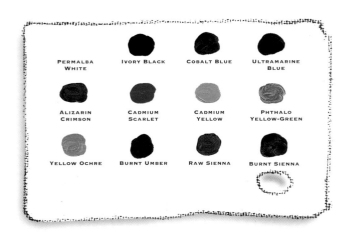

Permalba White · **Ivory Black** · **Cobalt Blue** · **Ultramarine Blue**

Alizarin Crimson · **Cadmium Scarlet** · **Cadmium Yellow** · **Phthalo Yellow-Green**

Yellow Ochre · **Burnt Umber** · **Raw Sienna** · **Burnt Sienna**

Surface
Oil-primed linen

Oil paints

Permalba White	Cadmium Yellow
Ivory Black	Phthalo Yellow-Green
Cobalt Blue	Yellow Ochre
Ultramarine Blue	Burnt Umber
Alizarin Crimson	Raw Sienna
Cadmium Scarlet	Burnt Sienna

Brushes
Filbert and flats in several sizes
(bristle brushes to start with and red sable
or mongoose hairs in later stages)

Palette knife

POSITIONING THE SUBJECT

Using a big, 1-inch bristle filbert, I created a very loose and spontaneous sketch to position my big shapes. I was not too concerned with detail and likeness at this point so a big brush let me boldly cover a lot of ground. (As I always say, peewee brushes make for peewee paintings.) As usual, my paint was fairly heavy, not thinned with a medium. I created texture within the paint by varying the pressure I applied on the brush, making both narrow and wide brush strokes, some closer together for denser, darker areas and some farther apart for lighter passages. Some of the paint was even "pushed" into the canvas to create soft transitions.

ESTABLISHING THE SHAPES

In this stage, I turned my attention to the accuracy of the drawing — to the placement of the big shapes and the proportions. I also established some of the smaller elements in the face and shirt. Notice that I didn't put in any hard edges or definite lines, though. I loaded my brush with fairly heavy paint, wiped some of it on my palette, then drybrushed over the surface to keep the strokes loose, allowing the texture of the linen to come through. I stuck with a bristle filbert, using Yellow Ochre and Cobalt Blue in the face and Burnt Umber, Phthalo Yellow-Green, Yellow Ochre and Black in the background.

"I apply my paints or pastels with variety right from the initial block-in so that my textures appear fresh and lively in the finished painting."

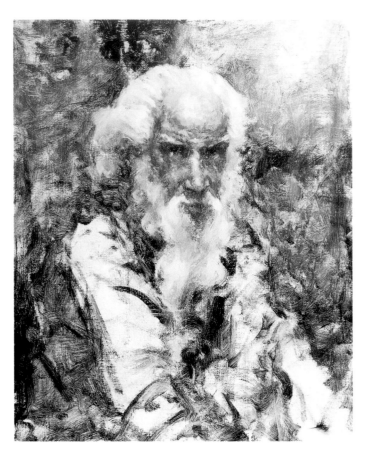

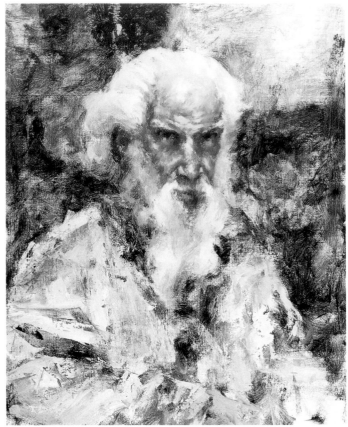

ENHANCING VOLUME

Once I'd built a solid foundation of shapes all over the canvas, I started bringing Luke out of the background. Using more Yellow Ochre, plus Cadmium Red and a touch of Cadmium Yellow, I put more middle tones in the face, then added darks and then lights with short "chunks" or strokes of color to create the sensation of old, wrinkled skin. To keep the white hair from looking flat, I used Permalba White and adjusted the values as needed to create the three-dimensional form of the head. I didn't try to paint every strand of hair. A few visible "hit-and-run" brush strokes here and there in both the brightly lit and shadowed areas were enough to suggest the texture of his hair.

REFINING THE DRAWING

With a brush, I put more of the same colors onto the face to refine the different values within the forms, which gave them better definition. I also began to develop the shirt with a palette knife, incorporating some of the warm face and background colors into it for a better flow of color. I switched to a palette knife because I'd already used a lot of drybrushing and it was getting monotonous. As I worked on the shirt, I realized that shifting the position of the arm on the left would allow me to put in a dark accent at the elbow, which would continue the line of dark accents along the left side of the painting.

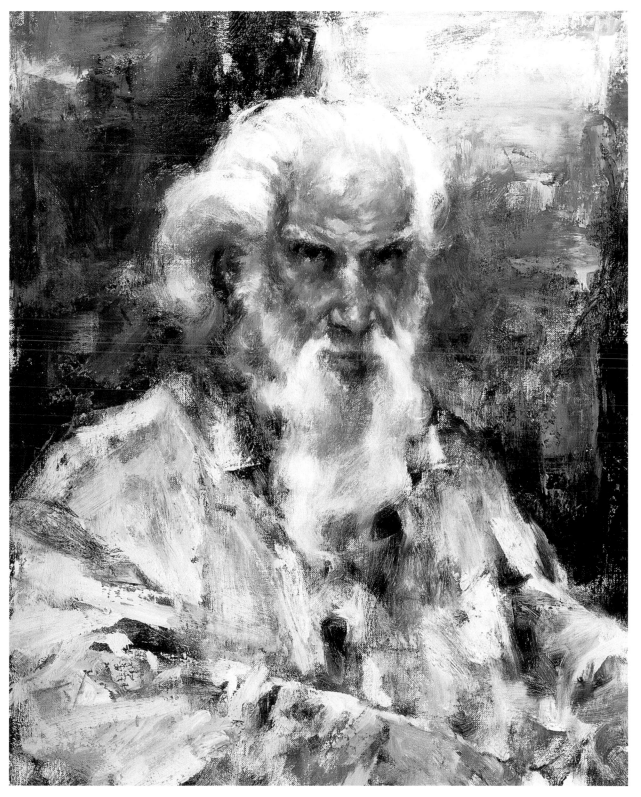

POLISHING WITH TEXTURE

*After changing the arm on the left, I felt the shoulder on the right fell away too quickly, creating an imbalance, so I changed its position. But I wasn't quite satisfied with the face — I felt I could make the colors more accurate. To intensify the contrast between his dark skin tones and white hair, I added more paint which I had to blend. This meant a tough fight to hang on to the wrinkled skin texture, and I had to sacrifice some of it, but it was a necessary change. I used smaller, softer red sable and mongoose hair brushes to make these fine additions. Finally, I used a palette knife to smooth out, cover and re-introduce a few color-shapes of purple and green in the background of **"Portrait of Luke", oil, 20 x 16" (51 x 41cm)**.*

The *4 other* ESSENTIALS

Composition

A classic portrait pose like this usually ends up dividing the painting into a large triangle at the bottom topped by the round shape of the head. This can look too simplistic, which is why I broke up this background into three shapes. Imagine how dull this area would have been as one big shape.

Value

Painting white objects can be tricky, but I've learned to use darker-valued variations of white to create the illusion of three dimensions. Here, I mixed the white with touches of Cobalt Blue, Yellow Ochre and Phthalo Yellow-Green to bring down the value for the shadows.

Color

Both kinds of color contrast work in this painting. The warm tones of the face are balanced by mostly cools in the background, with a few touches of warm green for integration. I allowed the face to have the brightest colors, but brought some of its violet tones into the purple shirt and repeated some of the green-grays in the beard and background, again to unify the painting.

Focal point

I used paths of dark accents, as well as the edges of my surrounding shapes, to lead the eye into the focal point. Greater definition and brighter colors also draw attention to the face.

CHOOSING THE BEST SURFACE

Knowing that I wanted to paint this subject very impressionistically with a lot of loose texture, I chose a rougher linen, which has more tooth than a portrait canvas, for **"Christian with Art Book", oil, 18 x 14" (46 x 36cm)**. *However, for contrast around the focal point, I built up his face with heavier paints in a smoother texture. This painting won the Allied Artists of America's Grumbacher Gold Medal Award.*

THE ESSENCE OF TEXTURE

Texture can be used to describe the surfaces in your subject, to add a decorative quality to a painting or both. The secret is to put a range of calm to exaggerated textures in every painting. To create variety, study the two main sources for texture:

- Experiment with surfaces having different kinds and degrees of texture. Buy them ready-made or make your own.
- Experiment with applying your medium, using different degrees of texture, different types of strokes and even different application tools.

POWERFUL PAINTING
with Focal Point

Every painting needs a main character, a "star".
Lead your viewer right to the center of attention
with shapes, and let your star shine with contrasts of
value, color and texture.

A traditional painting is like a story — it has to have one main point. In painting, this is called the focal point. Whether it whispers or shouts for attention, the focal point is always the dominant character in the painting, the area that attracts the eye first and keeps attracting the eye again and again, even as the viewer looks at the rest of the painting.

When I first started painting, I wanted to get to the focal point immediately so I could finish the painting in a few quick moves. But I soon realized that I have to work up to the focal point by dealing with all of the other essential concepts — shapes, values, colors and texture — first. They provide the foundation for the focal point, allowing it to take center stage. Now I use these essentials, plus another key concept called edges, to lead the eye into the focal point and keep it there.

Making decisions up front

Before I begin a new painting, I determine which area is going to serve as my focal point. I usually pick the area that is already most interesting, knowing that I can enhance it as I progress. However, I do not pick a whole object for my focal point. Paintings are far more interesting when the focal point is only part of an object or encompasses a few parts of several elements.

Following the simple guidelines I explained in the first section on Composition, I then think about the focal point in relation to the rest of the shapes in the composition. In general, I want the other shapes to somehow lead into the focal point, either with the direction of their edges, with value or with color.

I also concern myself with the position of the focal point on the canvas or painting surface. Academic tradition says that the best places to position a focal point is in the center of any of the four quadrants of a painting. To envision this theory, imagine dividing the surface into even thirds across and down with invisible lines. Traditionally, the four intersections of these four lines are considered the most ideal locations for a focal point. Sometimes I follow this advice because it does work, but I also like to challenge myself by placing the focal point in the center or in some other unusual location.

CHOOSING GREAT SHAPES

*Inspired by the pigeons scouting for food around our table at a New York City outdoor café, I decided to do a portrait of this pair of birds. The fantastic, dynamic shapes of the birds viewed from this angle were sufficiently interesting to make them the focal point of **"Chow Time"**, **pastel over watercolor, 19 x 25" (49 x 64cm)**. Their pointed wings also provided the idea for breaking up the background with long, straight strokes of color, both in the watercolor underpainting and the final application of pastel.*

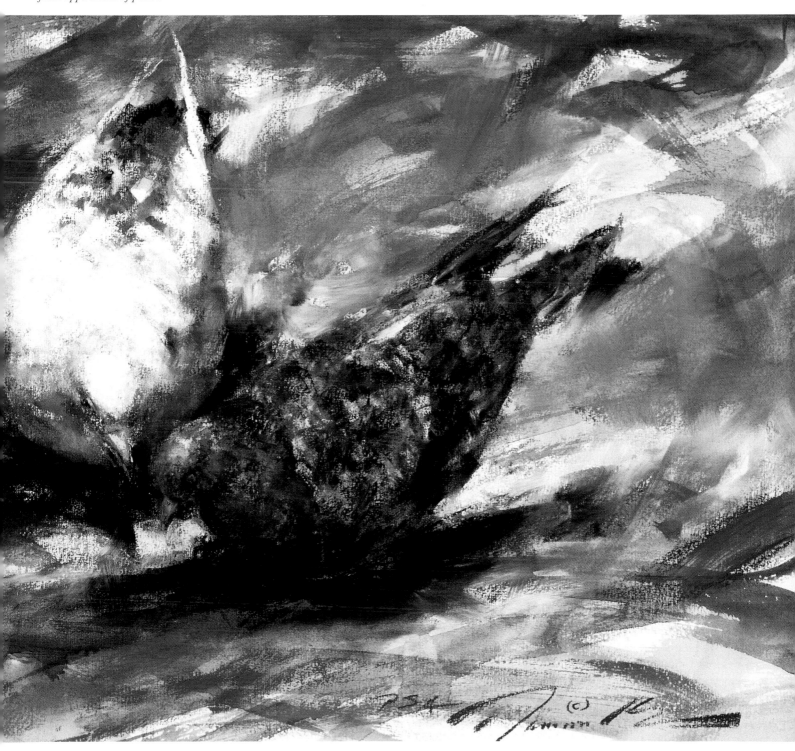

Finishing with a flourish

I get the focal point clear in my mind at the beginning, and keep it there right through the painting process, although I don't really paint the details that bring out the focal point until the very end. But by staying aware of it, I can set up and create various types of contrast that will ultimately make the focal point stand out.

For example, if I want the focal point to have a lot of light values, I'll scale down many of the values surrounding it, probably using both darker and leaner paints to achieve that look. If I want the focal point to have a lot of bright colors, I'll use duller versions of those same colors and other neutrals in the opposite temperature around it. If I want the focal point to have a smooth texture, I'll give the neighboring objects rougher textures. And if I want detail in my focal point, I'll get more vague and even go completely abstract as I move away from it. All of these choices made while painting lay the groundwork for my final steps.

For me, the very last stage is the most fun of all. If I've built a strong foundation, it doesn't take much to complete the effect, but I go slowly to make sure I do the right things. This is where I place a few final accents of both light and dark colors that act as stepping stones leading to the focal point. I also put in the brightest colors, highlights and other details, and tighten up the edges wherever I want the viewer's eye to linger. Depending on how far I go with any of these qualities, I can control how hushed or dramatic the focal point appears.

Holding your viewer's attention

As I said, the focal point of your painting should be like the high point of a story — everything else should lead up to it, but it should still be visibly different and unique. But don't forget to bring other parts of the painting up to differing degrees of "finish" or "polish" in order to create secondary areas of interest. Following this approach leads to exciting paintings that hold your audience captive.

USING THE POWER OF EDGES

Edges are one of the most important tools we have to direct the viewer's eye around a painting. This is because harder edges stop the movement of our eyes and make us linger, while soft transitions allow our eyes to pass freely through an area. A good artist will understand how this works, and wisely place the hardest edges in and around the focal point.

Let's examine how this works in **"Antiques and Oranges", oil, 24 x 30" (61 x 76cm)**. You know the center of the brass pot is the focal point because it has the brightest and lightest accents, plus the other shapes are all pointing to it. But look at the close-up details to see how I backed this up with edges. The rim and hinges on the brass pot have the crispest edges in the whole painting. Other edges are either softer or obscured because the two values on either side of the edge are so close. My use of edges is subtle but effective.

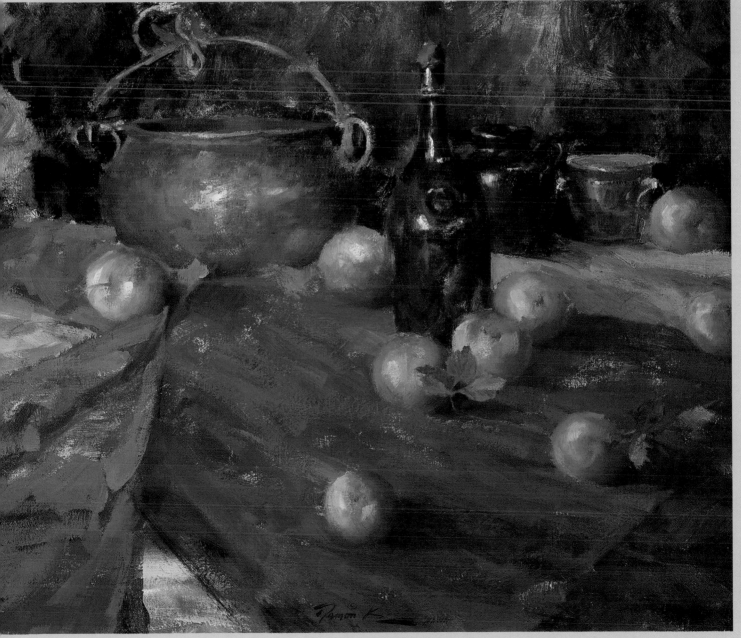

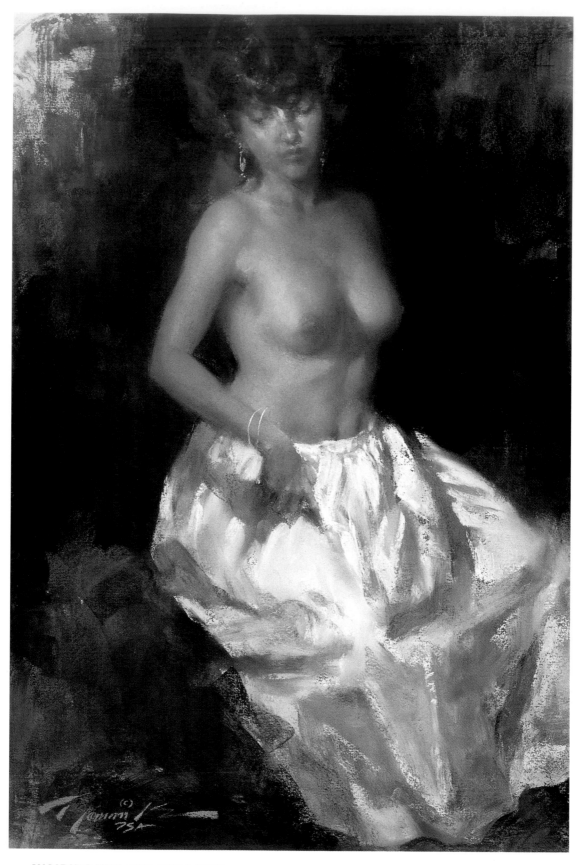

AVOIDING THE CUT-OUT LOOK

*When the main object in a painting is completely outlined with a hard edge, it looks as if it's been cut out from another painting and pasted onto a background. I never want this to happen in one of my paintings, which is why I always choose just one side or portion of an object to get the hard edge and serve as the focal point. You can see this very well in **"Colette Posing", pastel over watercolor, 18 x 12" (46 x 31cm)**, where the left edge of the figure is crisp and the right side fades into the background.*

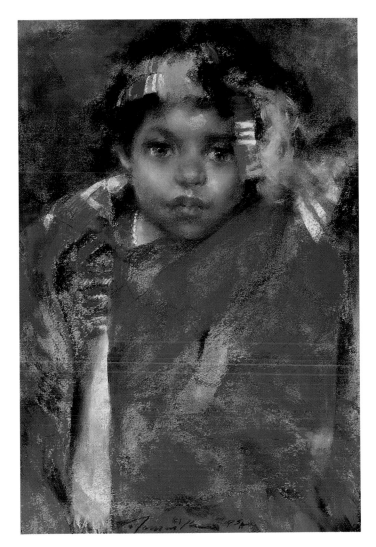

KEEPING THE FOCUS WHERE IT BELONGS

*Red is such a dominant color that the red poncho could have easily overwhelmed the girl's face in **"Indian Girl in Headdress", pastel, 18 x 12" (46 x 31cm)**. To keep the emphasis where I wanted it — on the face — I put my softest textures, greatest definition and highest contrasts of values in the face, then surrounded it with my brightest accents of color. There's no way this little model could get lost in this painting.*

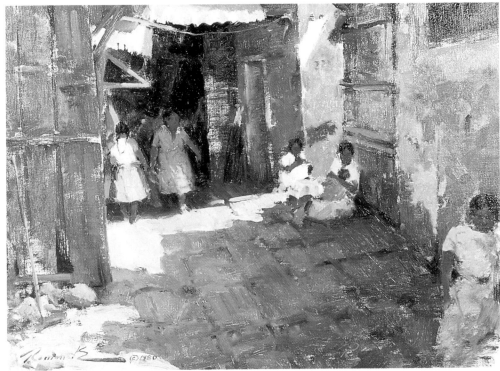

CONTROLLING HOW WE SEE

*Talk about directing the eye with shape! In **"Street Scene, Mexico", oil, 14 x 18" (36 x 46cm)**, I used the foreground shape, as well as the strokes within it, to point your eye toward the focal point on the far left. I also used the diminishing figure shapes in the foreground to create a series of visual stepping stones that lead you to the figures in the center. But I didn't want to lead you right out of the upper left corner, so I put a big vertical shape on the far left to stop your eye and push you back into the painting.*

107

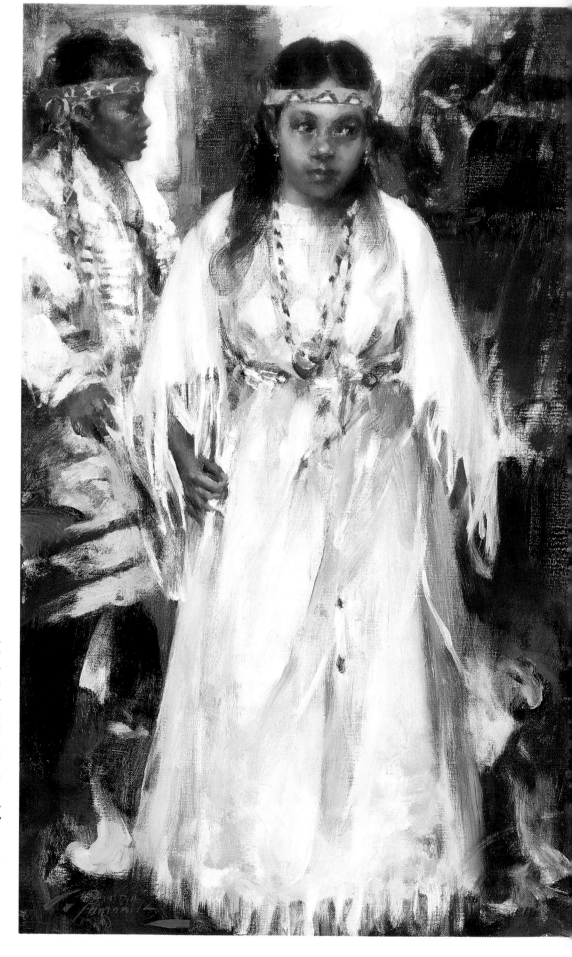

CHOOSING TO INCLUDE MORE

Occasionally, I like to paint moving subjects, such as this young dancer at an annual Crow Fair at the Crow Agency in Montana. The only way to do this is to work from a photograph. My photo of the girl included portions of the other dancers surrounding her, so I had a choice to include them in the painting as well or not. Eventually I decided to put them in **"Little Crow Dancer", oil, 20 x 16" (51 x 41cm)** *for added interest, but I painted them as almost abstract shapes in downplayed values and colors so they wouldn't detract from the main figure. These vague shapes give a nice hint of mystery to the work.*

REALISM VS IMPRESSIONISM

On the one hand, I want to paint somewhat realistically so that my viewers can recognize my subjects. But on the other hand, if I paint too realistically, my viewers will know what the painting's about right away, lose interest immediately and walk away. That would be terrible!

My solution is to paint what's in front of me, but to modify the values, exaggerate the colors and textures and generally make my subjects more exciting. I also let the secondary elements and backgrounds dissolve into abstract shapes and random strokes. Being somewhat vague in some areas creates mystery in my work. Then the viewer wonders what's happening and, therefore, spends more time looking at the painting. It also invites them to return again and again to find something new.

The great thing about being an artist is that you can choose how real or how exaggerated you want to get. It becomes a reflection of your personality and a hallmark of your painting style.

DARING TO BE DIFFERENT

"On a Spanish Wall", pastel, 9 x 11" *(23 x 28cm) proves that the focal point doesn't have to be one of the main objects in the subject. Here, that edge separating the black background shape from the white background shape offers the starkest contrast, so it attracts your eye first. From there, you can then move to secondary areas of interest, such as the flowers. Any portion of a painting can function as the focal point, as long as you make it obvious and interesting.*

DOING SOMETHING UNUSUAL

I don't like to be obvious. Instead, I like to
pick focal points that are a bit more unusual.
In **"Church Steeples", pastel, 9½ x 12¼"
(24 x 31cm)**, for example, the large church
would have been the most likely choice so
I put the focus on the smaller white building
behind it, which happens to be the center of
the painting. I used directional shapes and
contrasting edges and textures to make it clear.
Not only is it a more dramatic choice, it keeps
your eye from getting stuck on the biggest
shape and encourages you to explore the entire
painting.

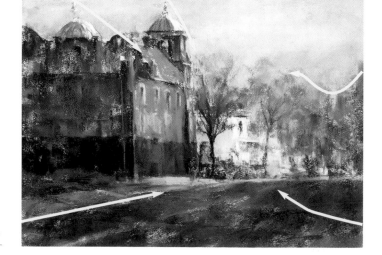

**THE EYEPATH FOR AN
UNUSUAL FOCAL POINT**

DETAIL

DETAIL

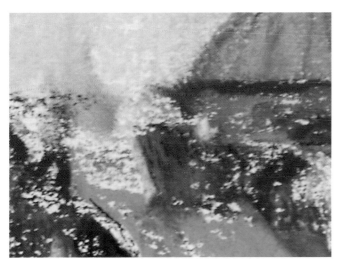

DETAIL

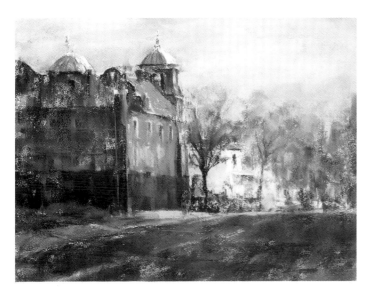

HOW THE FOCAL POINT FITS INTO
A COMPOSITION GRID

MY VALUE PLAN

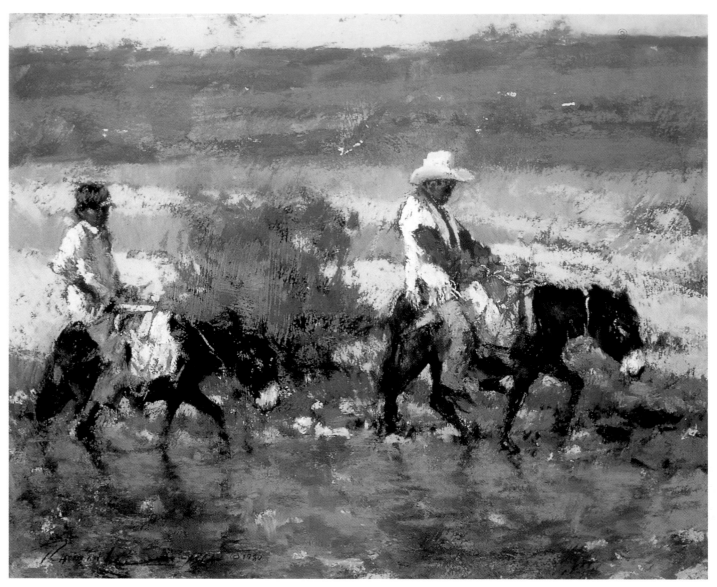

IDENTIFYING THE FOCAL POINT

*As much as I want my focal points to stand out, I don't want them to be completely divorced from the rest of the painting. In **"Burritos", pastel, 11 x 14" (28 x 36cm)**, that hot pink/red shirt is the brightest thing in the painting, most definitely the focal point. But I didn't want it to be isolated, so I put very subtle touches of reds and pinks in just a few other places around the painting. It was actually fairly easy to hide these quiet accents in a painting loaded with so much texture.*

STARTING WITH STILL LIFE

I can't stress the value and importance of painting still lifes enough. Not only is it a great learning aid, it's fun, too. Still lifes give me a chance to be creative with composition and lighting. Plus, I can do it any time, anywhere since my "models" are always available.

What I've learned most from painting still lifes is how to use value, hue and color temperature to make the four most common forms — spheres, pyramids, cubes and cones — look three-dimensional or at least believable. Once I had figured this out, I was able to paint any subject because almost every other object is constructed out of these same essential forms. Think about a tree trunk, a building or the human figure — they're all structured around these basics. Painting successful still lifes gave me the confidence to tackle more difficult subjects.

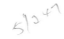

(RIGHT) SPOTTING THE FOCAL POINT

*Notice how only the lit side of the figure in **"Model Standing", pastel, 12 x 9" (31 x 23cm)** is the focal point of the painting. What separates it and makes it unique? First, of course, is the value, but this area also has smoother texture, warmer colors and the hardest edge in the piece. These distinctions make it the most dominant factor in the painting.*

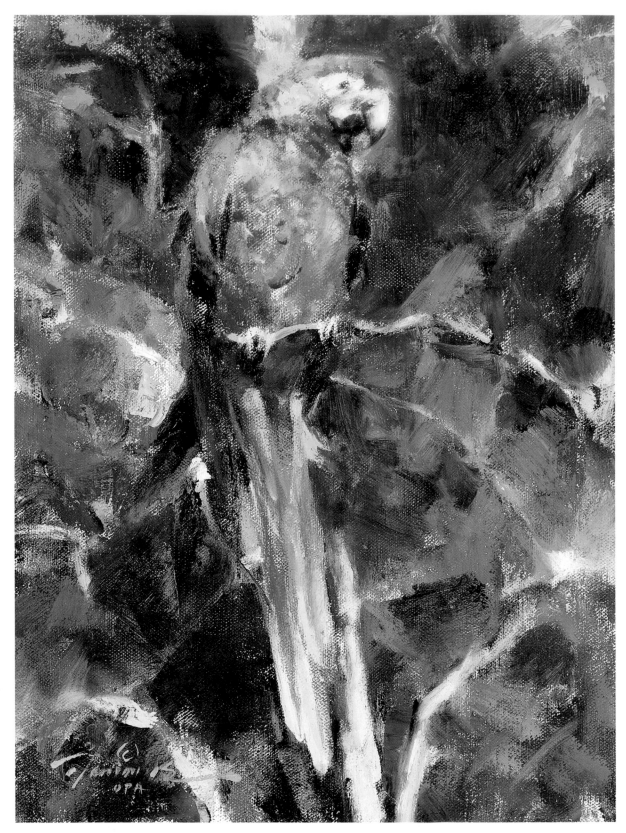

HARMONIZING THE WHOLE

Painting a picture of only one object, such as this parrot in ***"Papagallo", oil, 18 x 12" (46 x 31cm),*** *is a bit risky. Floating in the middle of the surface, the object can easily become an isolated little island. To retain the parrot's importance while integrating him into the background, I repeated strokes of his vibrant colors in the foliage. I also broke up the background into smaller shapes for variety, but notice how the lines still lead you back to the main character.*

ADDING PIZZAZZ

"Still Life with Blue Pitcher", oil, 18 x 24" (46 x 61cm) is loaded with different kinds of texture, which makes it so much more exciting. I began by priming hardboard with strokes made by a stiff, bristle brush, which left a random texture all over the surface. Then in many areas, I painted with a palette knife and allowed this rough surface to peek through the thinly applied paint. But for variety, I put in the smoother surfaces, reflections and highlights of the focal point with a brush. Together, the contrasting textures give the focal point greater impact.

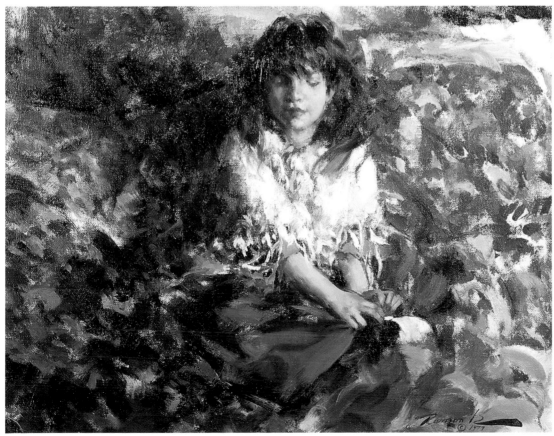

ANCHORING A PAINTING

What a great chiaroscuro painting! The model seems to be coming out of the darker background, as if emerging from a cocoon, in "The White Shoe", oil, 14 x 18" (36 x 46cm). The light values, bigger shapes and smoother texture within the focal point provide a nice resting place for the eye.

PROVIDING SOME CALM IN THE STORM

How do you make the focal point clear in a subject with this much activity? In "Ramoncito and His Toys", oil, 16 x 12" (41 x 31cm), I decided to fill the entire foreground with palette knife busy-ness, but then I positioned this little boy against a plain backdrop for emphasis. Some of the elements within the foreground are easy to recognize, but none have the power of the plainly recognizable boy. Edges and light accents within the foreground also lead into the focal point.

MY VALUE PLAN

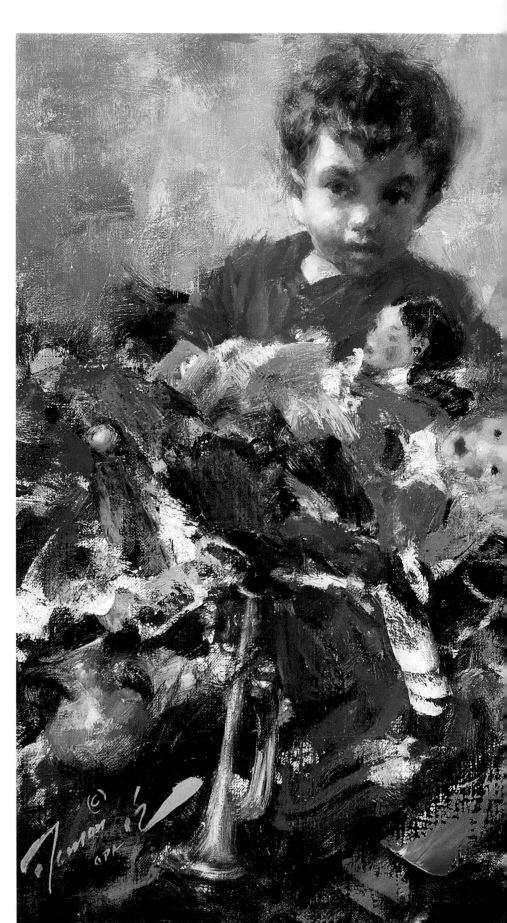

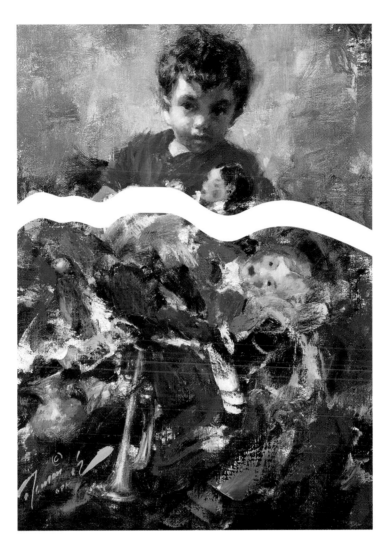

DIVIDING CALM FROM BUSY

You can clearly see the division of "activity" in this diagram.

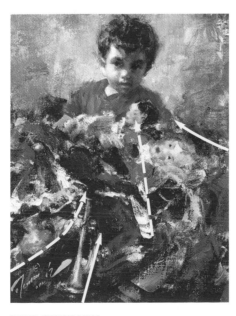

THE EYEPATH

THE COMPOSITION GRID

PUZZLING THROUGH TO A SOLUTION

To me, a painting should be made up of pieces that fit together like a puzzle. Actually, painting is often like assembling a puzzle because you don't always know which pieces will go where until you're almost finished. When I was painting **"El Capitan"**, **pastel, 20¹/₂ x 16" (52 x 41cm)**, I decided to break up the background into these three pieces because they offered the best fit and balance with the other shapes leading to the focal point, the face.

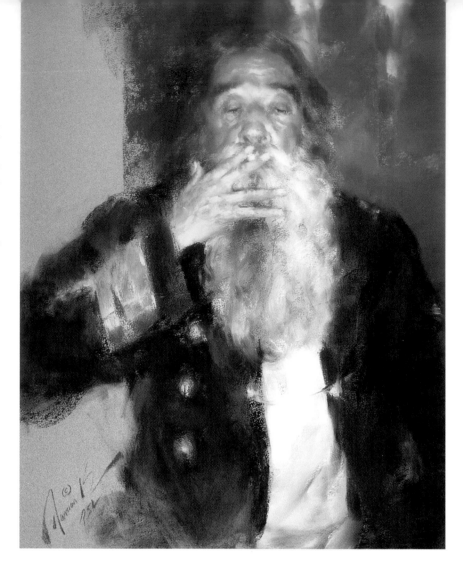

USING WHAT'S AVAILABLE

In a nearly monochromatic painting, such as **"The Spanish Monk", oil, 16 x 20" (41 x 51cm)**, color is obviously not an option in enhancing the focal point. Here, I had to rely on value and shapes to make it work. Notice how his head interrupts that long, very light rectangle. I also used a contrast of textures to make his face dominate the rest of the piece.

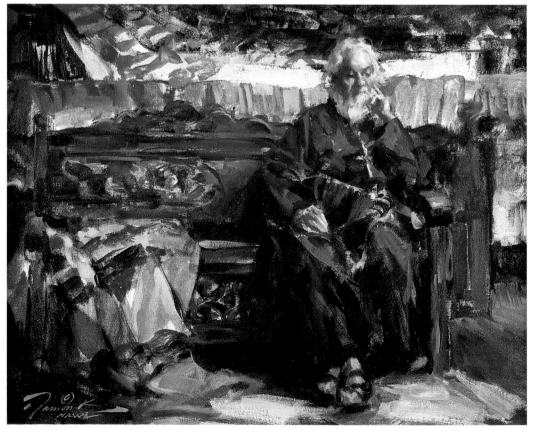

ART IN THE MAKING — "PREPARING FOR THE BATH"

DRAWING TOWARD THE FOCAL POINT

One of the things I like best about pastel is the variety of ways I can apply it to the paper. In this first step, I used the edges and sides of my sticks to make lines and flat strokes. I used Yellow Ochre and Cadmium Orange in the flesh, dark brown for the hair, warm white and yellows for the drapery, and dark gray, medium yellow and dark Crimson for the background. Notice how many of my strokes are already pointing toward the head.

In any portrait or figure painting, the head is almost always the focal point. Our eyes are just naturally drawn to other human faces. But in this painting, I wanted to do something a bit unusual so I turned her head away from us. This causes the viewer to ask questions — What is she doing? What's she looking at? It helps to create a mood of mystery. Knowing that I wanted her head to be the focal point made it easier to set this up with composition, values, colors, texture and edges as I painted.

LAYING IN MID-TONES AND DARKS

Once I was fairly certain that the placement of the figure was strong and the drawing correct, I began to put in more mid-tones and darks. These subtle value changes helped to model the legs, arms and neck, making them appear more round. I also began to develop the background by adding the brass jar and lightening the shape of the curtained window.

WHAT THE ARTIST USED

SURFACE
Warm gray drawing paper

PASTELS
A variety of brands of medium and soft pastels for most of the painting, and some hard pastels for fine detail and crisp edges in the final stages

BALANCING NEUTRALS WITH BRIGHTS

Natural-looking drapery is an important part of this painting, so I spent some time modeling the folds of the drapery in the same way I'd model any other forms with transitional values. I used these same light values for accents on her body. I also decided to put different shades of yellow across the floor to balance all the neutrals, but then they had to be reflected along the lower portions of the white drapery. These will tie in with the yellows and golds in her hair and in the jar.

LINKING THE BACKGROUND WITH THE FOCAL POINT

Because I like to be creative and push my paintings to the fullest, I decided to use a complete value scale in this painting. I smudged Burnt Umber and Burnt Sienna Deep with touches of black for a warm tone in select areas across the background. I repeated these same colors in her hair, and also added a cast shadow from her leg. Notice how these dark accents visually connect, leading your eye to her head.

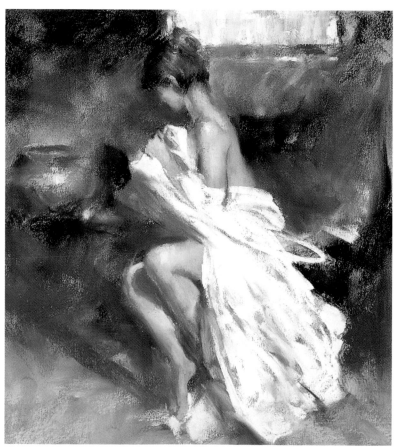

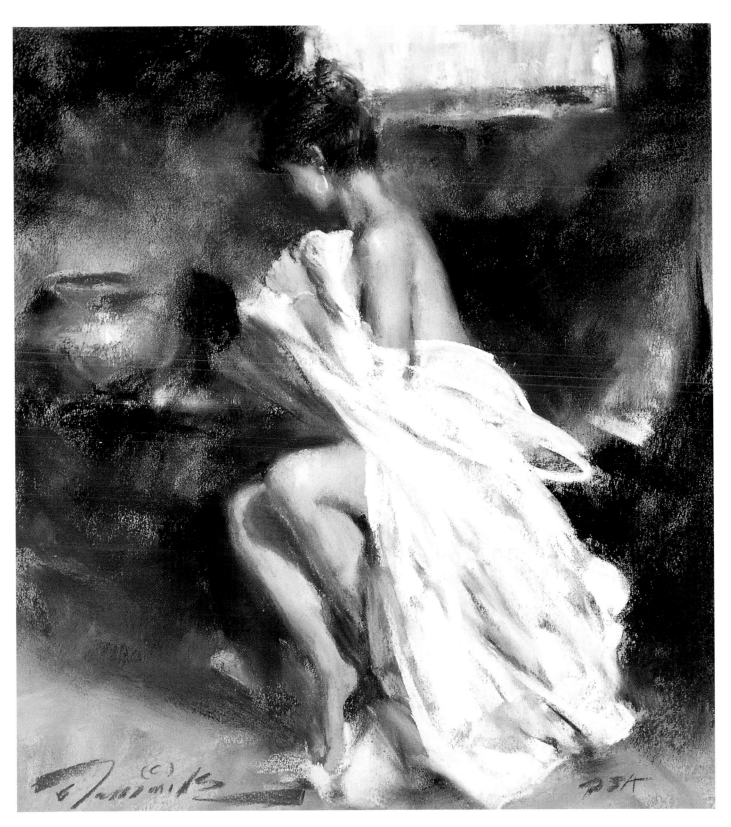

GIVING THE FIGURE MORE PROMINENCE

*Keeping in mind that the head is the focal point of **"Preparing for the Bath", pastel, 11 x 9" (28 x 23cm)**, I made a few adjustments to distinguish it more. Placing a light accent on her shoulder made a better transition from the body to the head. Then I added a light warm brown accent to the brass jar to give it a little more importance, but softened most of the other shadow shapes around her to contrast against her well-defined figure. Finally, I added another touch of warm yellow below the window so that the figure was entirely framed with touches of warm yellow light.*

121

The *4* *other* *ESSENTIALS*

Composition

A variety of big, dynamic shapes are essential to any composition. Here, I balanced the triangular figure with horizontal rectangles and a circle.

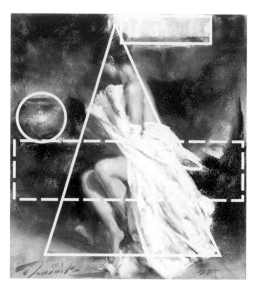

Value

Pathways of both light and dark accents lead your eye around this painting and into the focal point.

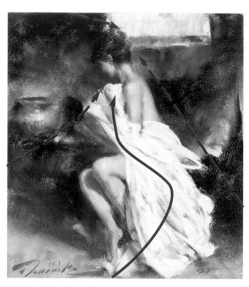

Color

I wanted to give this painting a rather quiet mood, so I used primarily neutrals. But notice how I framed the figure with spots of brighter yellows and golds for hushed excitement. Without these, the painting would have been dull.

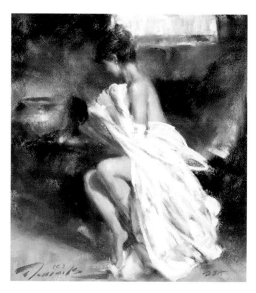

Texture

The loose, textured strokes of the background provide a nice foil to the smooth textures of her skin.

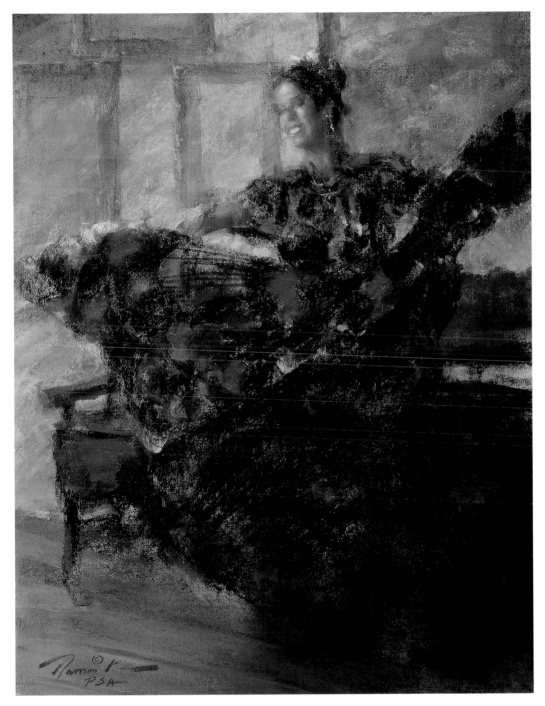

DIFFUSING THE FACE

As you know, a face can be a powerful focal point. But I don't always want the face of my figure to be the dominant element. In **"Spanish Flair", pastel, 24½ x 18½" (62 x 47cm),** *I wanted to put the focus on the beautiful rhythm of that skirt. This is why I softened the face and made it more vague, while making the skirt a huge, dark shape with plenty of bright accents.*

THE ESSENCE OF FOCAL POINT

In a traditional painting where there's a fairly clear or obvious subject, one small portion of the painting needs to be designated as the most important area — the focal point. Choose which area you want to use as your focal point, and create a foundation for it with the other concepts.

- Let the shapes and the values of those shapes lead the eye into the focal point.
- Make the focal point different from the rest of the painting in terms of value, color, texture and edges. The contrast will bring out the focal point.

Equipping the Studio

I like to joke that I'm a "junker", but it's true that I do love to collect things. So when you first walk into my studio, it looks like an antique shop. Over the years, I've collected a lot of interesting old items to use as props in my paintings and just for decoration. I like having handcrafted things around because these "works of art" inspire me.

Of course, not everybody needs or wants to have all this stuff. What an artist really needs is a dedicated space for painting. My first studio was the living room of our first apartment, and my second studio was the garage of our first house — I used what was available! You can, too. If you really want to paint badly enough, you'll carve out a space where you can set up your materials and leave them. Then you'll be ready to work the moment inspiration hits.

Setting up a complete studio all at once can get expensive, so I encourage all beginning artists to invest most of their money in the materials themselves — paints, brushes, pastel sticks, surfaces and a good easel. Don't waste your money on "student grade" materials. You'll improve faster and get a better feeling for painting with the real thing.

Another smart investment is lighting. Start with a couple of portable light fixtures and buy color-corrected bulbs for illuminating your subject and your easel. It's also helpful to have a natural, preferably north-facing, light source, especially for portraits or nudes. (The warm colors of skin need the balance of a cool light source.)

As you progress, you can gradually add to your studio — more easels, storage racks, additional lights and so on. But look for things on sale or at store close-outs and garage sales so you can save money. You don't have to have all the equipment to get started. Focus on top-quality materials first and buy the other accessories as you go.

FOCUSING ON OILS

One corner of my studio is dedicated to my oil painting set-up. On one side of my easel is a tray where I keep my brushes, and on the other is my taboret. It's actually an antique table which I've covered with a piece of ³/₈" glass on top of a piece of off-white paper to create a palette. I rarely use a medium, but I keep odorless mineral spirits handy for cleaning my brushes.

PICKING OUT PASTELS

In another area, I keep my pastel set-up. I actually own far more pastel sticks than what's shown on my pastel table — I'm a color junkie — but I keep my favorites out at all times. I buy pastels from every manufacturer, so I have everything from very hard to buttery soft sticks.

Notice that I have large window off to the far right. East- and west-facing windows provide a nice natural, cool light source, which I prefer when I'm painting portraits and nudes. However, I also have large shades over the windows so I can block out the light when I need to.

"Setting up a complete studio all at once can get expensive, so I encourage all beginning artists to invest most of their money in the materials."

These pictures show several storage areas around my studio. Obviously, I've accumulated a lot of stuff over the years, such as great props for my still life and figure paintings. I've also built up an extensive collection of art books for reference and inspiration. In my early years, I didn't think much about storage but I learned that it's important to have clean, protective racks for storing canvases and frames, as well as large, flat drawers for holding drawing and watercolor papers and finished drawings and paintings. I also like to keep a number of frames in my favorite standard sizes around, so I can see which frame will work best on a newly completed painting.

ENJOYING ANTIQUES

The antique fainting couch on my model stand is perfect for all of my portraits, figure paintings and nudes. But I always paint from life. Rest assured, this antique English mannequin is just my buddy! Surrounding the model stand is one of my prized possessions — a hand-carved Italian pediment once owned by William Randolph Hearst.

TAKING TIME FOR PICTURES

I've also dedicated another corner of my studio as a photograph station. Here, I keep an easel and the proper photography lights set up so I can quickly and easily photograph finished paintings before they go out to my galleries. Every artist should get in the habit of photographing every painting before it's sold. You never know when you'll need a visual record of your work.

ABOUT RAMON KELLEY

As a young boy growing up in Cheyenne, Wyoming, Ramon Kelley used to draw in the margins of his school books. He went on to serve four years in the US Navy, but he quickly returned to his first love — drawing. He won a scholarship to the Colorado Institute of Art, where he discovered life drawing and got hooked on the idea of making a career in art.

By the early 60s, Ramon had settled permanently in Denver. Needing to support his wife and young son, he went to work as an illustrator and graphic designer, doing portrait drawings in the evenings. Eventually, he took his drawing portfolio to Jane Hiatt, owner of the Village Gallery in Taos, New Mexico. She agreed to become his first gallery representative. After she'd been selling his drawings for more than a year, she suggested Ramon move into color and paint. His career in fine art was off and running.

One by one, Ramon turned his attention to various media. His first watercolor painting was accepted into the American Watercolor Society's annual exhibition, where it won the Helen Gapen Oehler Award. At the same time, Ramon adopted pastel and became one of the earliest members of the Pastel Society of America. He also took up oils and acrylics, and tried his hand at many other media, including sculpture.

Fueled by a passion for excellence, Ramon set about educating himself through many means, a practice that continues today. In addition to experimenting with different media and studying the work of his peers, Ramon enjoys collecting art books that offer insights into the great artists of the past. Among his favorites are Nicolai Fechin, John Singer Sargent, Anders Zorn and Antonio Mancini.

Over the years, Ramon's robust, bravura approach has evolved into a distinctive style. It is neither traditional nor modern, but a unique and timeless look. He now uses mainly oils and pastels, although his range of subjects is quite broad. He enjoys painting still lifes and landscapes, but is best known for his portraits, figures and nudes.

Today, Ramon's award-winning artwork is well recognized the world over. His work has been exhibited in one-man and group shows from Tucson to Taiwan, and his memberships in the Allied Artists of America, the Pastel Society of America, the National Academy of Western Art, Knickerbocker Artists, Oil Painters of America and the American Watercolor Society reflect the high caliber of his paintings. In 1986, he was elected to the Pastel Hall of Fame by the Pastel Society of America. His sensitive character studies

are included in the collections of the Seattle Frye Museum, the Santa Fe Museum of Fine Art, the Denver Public Library, the Spokane Museum of Native American Cultures and the Academy at West Point, among numerous other public and private collections.

In addition to painting, Ramon is a world-class teacher and has been featured in more than 15 art magazines and books, including two previous art instruction books: "Ramon Kelley Paints Portraits and Figures" and "How to Paint Figures in Pastel". Live demonstrations and instruction are what Ramon loves best about teaching, which is why he hosts a workshop each summer.

While Ramon has worked very hard to be successful in his career, he says his family — his wife Mona, his children Adam, Ben and Lea, Ben's wife, Vicki, and their son Max (his first grandchild) — remain his top priority. In fact, it was probably Ramon's example that inspired his sons, Ben and Adam, to become accomplished artists in their own right. However, Ramon's success has not dulled his passion for excellence, nor has it affected his personality. Ramon Kelley is still a very grounded, honest, humble person with a great sense of humor who continues to challenge himself in his profession.